The West C
Last Line of Defence
Taunton Stop Line

Andrew Powell-Thomas

AMBERLEY

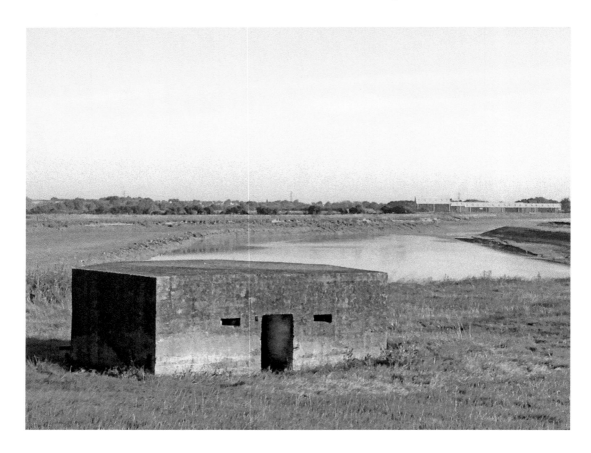

First published 2017

Amberley Publishing
The Hill, Stroud, Gloucestershire, GL5 4EP
www.amberley-books.com

Copyright © Andrew Powell-Thomas, 2017

The right of Andrew Powell-Thomas to be identified
as the Author of this work has been asserted in
accordance with the Copyrights, Designs and
Patents Act 1988.

ISBN 978 1 4456 6250 3 (print)
ISBN 978 1 4456 6251 0 (ebook)

British Library Cataloguing in Publication Data.
A catalogue record for this book is available from
the British Library.

Origination by Amberley Publishing.
Printed in Great Britain.

Contents

Introduction

Asked to think about the Second World War and your mind will instantly jump to a number of images: a smouldering London waking up to another night of bombing during the Blitz; fierce fighting by the 'Desert Rats' in the scorching heat at El Alamein; Adolf Hitler addressing thousands at a Nazi rally; the black and white images of the D-Day landing beaches in Normandy; Winston Churchill and his 'V' for Victory sign; or the sickening scenes as the horror of Auschwitz was revealed. Understandably, you would not instantly think of the open countryside of Somerset.

But Somerset does have a Second World War history. Admittedly, it is one not as heroic or well known as others, but instead it is a history of a nation preparing to defend itself in a time of utmost peril. It is a history of the everyday man, preparing to defend their freedom and way of life in the face of adversity. It is a history that is largely unknown by the majority, but is well preserved and accessible to all. It is the history of the Taunton Stop Line.

Containing around 400 structures, the Taunton Stop Line was a defensive wall that stretched for approximately 50 miles across Somerset, a small part of Dorset, and a few miles of Devon. Although built over seventy-five years ago, a large majority of the stop line remains intact today and this book aims to provide the locations of some of the emplacements that can still be found. With so many recorded structures, it is not meant to be a definitive guide, but an overview of this piece of local Second World War history. It aims to provide some background and insight to the localities and their roles during the war, which possibly help to explain the significance of the stop line passing nearby.

The Taunton Stop Line provides the West Country with a rich wartime history that is just waiting to be explored.

Chapter 1

'Peace for our Time'

It was on 30 September 1938 that British Prime Minister Neville Chamberlain returned to Heston Aerodrome from his meeting with Adolf Hitler in Munich, with that now infamous claim that, in allowing Nazi Germany to add Czechoslovakia to the already annexed territory of Austria, there would be 'Peace for our time'. However, this promise was short lived, and with the Nazi invasion of Poland less than a year later in September 1939, the Second World War began.

As the first year of the war rumbled on, and Hitler added Denmark, Luxemburg, Belgium, the Netherlands, Norway and north-eastern France to his list of conquests, the government, and indeed the vast majority of the population, firmly believed that a German invasion of British soil was imminent during the summer and autumn of 1940. With the majority of operational units already in France as part of the British Expeditionary Force (BEF), thoughts turned to defending the islands with what they had at home.

On 27 May 1940, General Edmund Ironside (promoted to Field Marshall in August that year) was appointed Commander-in-Chief of the Home Forces. In this role, he commanded a force of Territorial Infantry Divisions, home-defence battalions and the Local Defence Volunteers – which later became the Home Guard. Although significant in their numbers, with over 1.5 million in the Home Guard by the end of June 1940, these units lacked the sort of training, equipment and organisation that regular troops had. To help compensate for these deficiencies, Ironside began laying out plans for the static defence of village strongpoints throughout the country by the Home Guard, and by mid-June, pillboxes were being constructed.

The fall of France and the evacuation of the second BEF towards the end of June 1940 must have really heightened the sense of urgency with which defences on British soil were being prepared and, subsequently, on 25 June 1940, General Ironside announced his plans for Home Defence to the assembled masses of the War Cabinet deep underground in Whitehall, central London:

1. A defensive crust along the coast, able to fight off small raids and delay any landings.
2. Home Guard roadblocks at crossroads, valleys, and other choke points.

3. Static fortified stop lines sealing the Midlands and London off from the coast, and dividing the coastal area into sectors.
4. A central reserve ready to deal with a major breakthrough.
5. Local mobile columns ready to deal with local attacks and parachute landings.

The aim of the stop lines was to hinder, entangle and delay the advancing German forces. With the Maginot Line in France as the benchmark, though hopefully learning from the serious strategic flaw it had whereby the German Wehrmacht simply went around it, the engineers and planners quickly drew up plans for around fifty static fortified stop lines across the country. They were to be formed by a combination of concrete pillboxes, gun emplacements and trench systems, manned by the Home Guard; anti-tank obstacles, minefields and barbed wire entanglements; and, crucially, they were to utilise the natural and man-made features of an area such as rivers, canals and railway embankments.

One of the major lines to be built was the Taunton Stop Line, where the rhynes and boggy conditions of the Somerset Levels were seen as the perfect place to defend the capital, and the industrial heartland of England in the Midlands, against a Nazi invasion and advance from England's south-west peninsula.

Chapter 2

An Overview of the Taunton Stop Line

Up to this point, the South West of England had largely been unaffected by war. Aside from the call-up of men to the armed forces and the strategic importance of Plymouth's dockyard, the Bristol Aeroplane Co. and the harbour at Bristol, the main impact of the war had been in providing refuge to some of the 3.5 million evacuees from the big cities and ensuring agriculture was as productive as possible! That was all to change as the Taunton Stop Line was developed with alarming speed in June and July 1940. The 516th Corps Field Survey Company Royal Engineers carried out a survey and prepared detailed maps for the construction work to begin immediately. The 551st Army Troops Company Royal Engineers carried out the work in the south, while the 552nd Army Troop Company Royal Engineers worked on the northern sections. A company from the Auxiliary Military Pioneer Service, which consisted of intellectual refugees from Europe, typically Jews and political opponents of the Nazis, helped to re-excavate the Taunton–Chard Canal. Local labour was also used to help with the construction, with civilian contractors John Mowlem and Charles Brand & Son providing workers, and, astonishingly, the whole project of over 400 sites was completed within a mere five weeks.

The Taunton Stop Line extended for almost 50 miles, heading north to south, running through Somerset, Dorset and Devon. Starting at the coast near Highbridge in North Somerset, the line of defences ran down from the Pawlett Hams and along the River Parrett to Bridgwater. From here, it tracked the bank of the Bridgwater & Taunton Canal southward to Creech St Michael, where it then joined and followed the dried-up bed of the old Taunton & Chard Canal. Near the village of Ilton, the stop line traced the route of the Great Western Railway southward until it reached just north of Chard Junction, where it then followed the route shared by the Southern Railway and the River Axe. Here, it briefly crossed over into Dorset in a couple of places, and then finally followed the course of the River Axe into the seaside town of Axmouth, Devon, where the stop line ended.

Planners very deliberately used the rivers, canals and railway embankments of the area as the backbone for the stop line, peppering the route with a variety of anti-tank obstacles such as concrete posts, cubes and pyramids; ditches and barbed wire entanglements; road and rail blocks, as well as landmines. Many bridges had charge chambers cut into their foundations, ready for demolition should the enemy

look like gaining control of them, and a variety of pillboxes were constructed across the whole length of the line. In 1941, to strengthen the line and deny access to the major east–west routes that passed through the line, twelve 'Defensive Islands' were added at areas like Bridgwater, Creech St Michael and Chard. By early 1942, the Taunton Stop Line was at its peak and was defended by a staggering 300-plus rifle and light machine-gun pillboxes, typically for two or three men armed with rifles or Bren guns; sixty-plus medium machine-gun emplacements, typically for a group of men with the Vickers machine gun; and twenty-one static anti-tank gun emplacements, equipped with the much larger former First World War naval 6-pound guns.

Orders were given for the careful disguise and camouflage of pillboxes and the other field defences. They were to be dug into the ground, inserted into a hedgerow or hillside, or simply have soil piled up on the roof and sides. In addition to the use of paint and netting, the local materials available in the region were often used, with concrete made using beach sand, or a structure being covered by beach pebbles or stone from a nearby cliff. Indeed, six pillboxes in Somerset are said to have been coated with a mixture of cow manure and mud topped with straw as a form of natural concealment. Close to Axminster, a pillbox was disguised as a Romany caravan and, during the summer, a scarecrow 'family' and a horse made of straw were dressed and suitably arranged around the caravan to help it blend into the background.

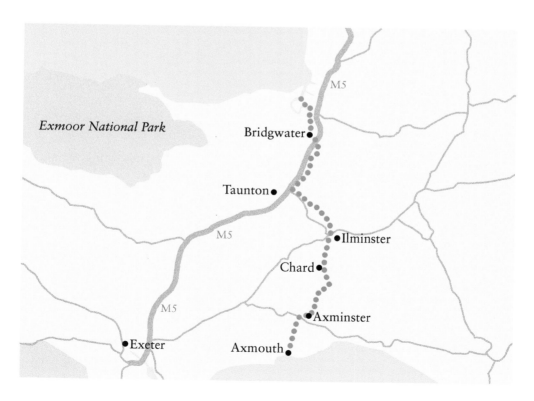

A number of other simplistic defensive measures would complement the stop line, such as the removal of signposts and railway station signs to disorientate and confuse any enemy invader. Near the coast there are records that show some petrol pumps were removed from service stations and plans were of course drawn up to destroy anything that would be useful to the enemy, such as bridges, roads and railway facilities.

The initial plan for manning the stop line was to use units of the army: with 48 Division of VIII Corps based at Taunton taking the lead role, and the 143rd Infantry Brigade Group based near Ilminster as support. The Home Guard's role was to assist the Field Army by acting as guides, keeping stores stocked and ensuring the sections of the stop line were maintained. However, as the army units were gradually withdrawn from the line, the Home Guard soon became solely responsible for manning the defensive positions.

Chapter 3

Somerset: Pawlett to Bridgwater

The small village of Pawlett, around 4 miles to the north of Bridgwater, is a tranquil and serene place to begin the Taunton Stop Line, but its significance shouldn't be underestimated. Situated on a bend of the tidal River Parrett, and just 1 mile from its mouth at Burnham-on-Sea, the surrounding farmers' fields on Pawlett Hill have sweeping views over the flat Pawlett Hams and the Bristol Channel beyond, and it is in these fields that a number of emplacements can be found.

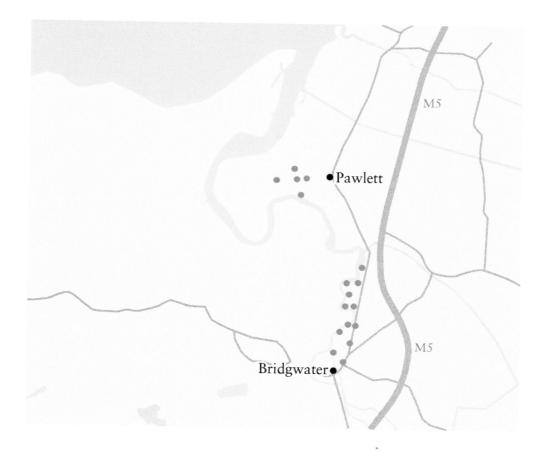

Pawlett was also the site of an RAF research station looking into anti-barrage balloon warfare during the Second World War, due in part to the vast expanse of open fields and the lack of people living there. Focusing primarily on ways to use cable cutting devices on aircraft wings, a huge hangar was constructed, measuring some 100 feet (30 metres) by 70 feet (21 metres) and around 80 feet (24 metres) high, so that the balloon, filled with a mixture of hydrogen and air, would not need to be deflated each night, and that repairs and maintenance could easily be carried out. The brave test pilots, probably flying in from RAF Culmhead on the Blackdown Hills, would have flown their aircraft into the cables to test the effectiveness of a range of cutters. The German barrage balloon cables had a 1-ton breaking strength and were lethal to low-flying aircraft, so the experimental work continued here until 1944.

Located near Gaunt's Farm and incredibly still standing today, the derelict rusty hanger, which sits on private land, has a pillbox less than 50 metres away from it on Ham Lane. Sadly overgrown, little can be seen of it today, but continue for another quarter of a mile north and another pillbox is clearly visible at the entrance to a field, by a drain. Turning right onto Chapel Road, there were another three Bren gun emplacements, now buried deep in the hedgerows. Back on Gaunt's Road, three more emplacements, no more than 150 metres apart, are set back off the road and behind the current hedgerow, protecting the entrance to a field that used to contain the ancillary buildings of the RAF research station. Although the field is now private property, if you look carefully enough you can make out another emplacement right in the middle of it, with a clearly stunning range of vision over the Pawlett Hams.

Heading down from Gaunt's Farm towards the River Parrett itself, you find yourself in the vast open expanse of the Pawlett Wetland Reserve, which has the partial remains of a navigation beacon, and further down, following the public footpath along the water's edge, you can find a solitary pillbox sat snugly on the north bank with a wide arch of fire, clearly located to surprise any on-comers heading up from the Bristol Channel.

Following the public track along the banks of the River Parrett, you come to a sharp bend just before Dunball Wharf where there are two Type 22 emplacements around 500 metres apart that have commanding views over the river. Still in commercial use today, Dunball Wharf was used during the Second World War to unload supplies, particularly that of coal from Wales, to the nearby Royal Ordnance Factory (ROF) Bridgwater. The small industrial estate that exists today is on the site of the hostel accommodation that was built for single workers at ROF Bridgwater. Located just to the north-west of the town, the massive 700-acre ROF Bridgwater was a vitally important factory producing high explosives for munitions. On the orders of the Ministry of Supply, construction work began in 1939 and by August 1941 the factory was producing RDX, an experimental new explosive more powerful than TNT and widely used by all sides throughout the remainder of the war.

The river slowly meanders south, where there are a further seven structures before you finally get to Bridgwater Docks. These emplacements, which are in extremely good condition, are in such tranquil surroundings that the men on duty here in the 1940s could easily be forgiven for forgetting all about the threat of invasion. Located along

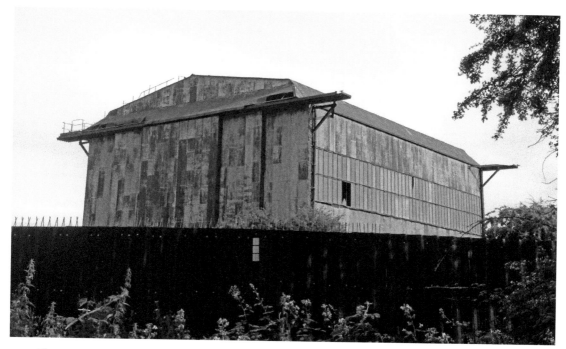

The imposing, rusty hanger of the RAF research station on the Pawlett Hams.

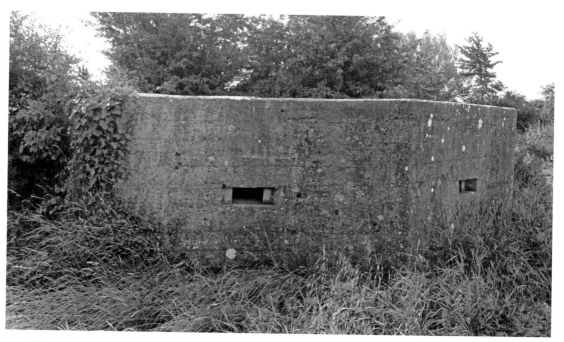

The Bren gun emplacement at the top of Ham Lane is partially covered by the surrounding vegetation.

The only accessible pillbox on Gaunts Road, with views right across the fields to the river.

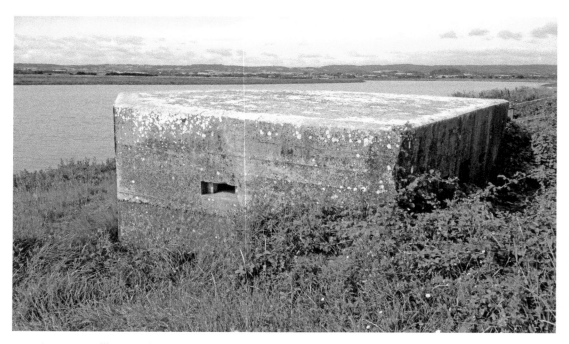

A remote pillbox on the north bank of the River Parrett.

The remains of a navigation beacon can still be found on the Pawlett Wetlands Reserve.

the banks of the River Parrett and alongside a very well-maintained public right of way, all the structures are untouched by modern development. They have no signs of being overrun by the natural environment and access inside them is possible, so long as caution is taken. The pillboxes along this part of the stop line, and the vast majority across the whole 40 miles of local defences, are the standard Type 24, which were an irregular hexagon in their plan. The rear wall was often the longest at approximately 4 metres and had at least one gun loophole (although the vast majority in Somerset seem to have two) as well as the entrance, while the rest of the walls had Bren gun embrasures. The walls were always built to at least bulletproof standard of 12 inches (30 cm) thick. However, many of the pillboxes here have shellproof walls that are in the range of 36–50 inches (91–127 cm) thick.

Heading out along the public footpath from Dunball Wharf, south towards Bridgwater, it is only 300 metres or so before the first pillbox is found near an electricity pylon. With a clearing around it, this is one of the few pillboxes across the entire Taunton Stop Line where it is possible to explore the whole of the outside and then safely enter too. On doing so, you quickly realise how small the entrances actually were, with the majority of people needing to stoop down to get inside. Once through the opening, there is a fairly significant step down into the pillbox, which, nowadays,

is often sadly cluttered with rubbish and debris – most of it human. Taking great care at this point, you are required to turn either right or left as there is a solid blast/anti-ricochet wall right in front of the doorway. Used for protecting those inside the pillbox from bullets and shells during an attempt to be taken, the wall is generally in a 'T' or 'Y' shape, with the top of these closest to the entranceway. This internal wall also gives support to the concrete roof, which partly explains why so many structures are still standing in such good condition today. Once inside and past the internal wall, the most striking thing, aside from how small it is, is just how dark it is. The loopholes are understandably small and as a result let in minimal daylight, but because of the internal anti-ricochet wall, very little light from the entrance makes its way into the centre of the pillbox. It only takes a little bit of imagination to put yourself into the shoes of a member of the Home Guard on duty in one of these more remote pillboxes and appreciate how they might have felt isolated in complete darkness, especially during a blackout.

Following the footpath for a further 500 metres leads you to the next pillbox, which is sat proudly on a bend in the river. Around 1 mile from Dunball Wharf, and within clear sight of the previous pillbox, it has an excellent view right up the river and is set out in an identical way to its neighbour. Just behind is another structure that is partly obscured from sight of the river. The entrance appears smaller due to the length of

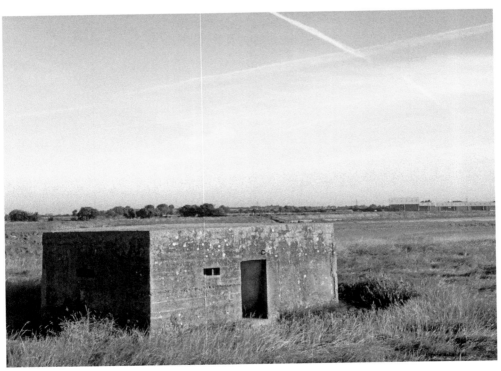

One of the most easily accessible pillboxes on the entire Taunton Stop Line – within sight of Dunball Wharf.

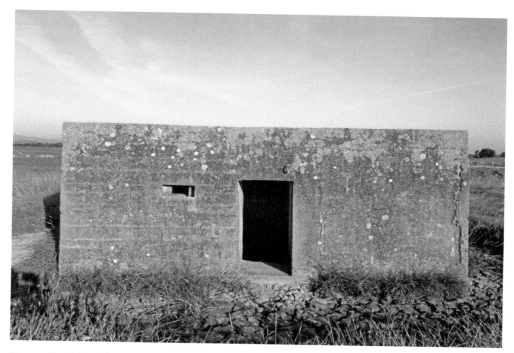

Unusually, this pillbox only has one gun loophole on the entrance side.

The view of Dunball Wharf (to the right) from one of the Bren gun loopholes.

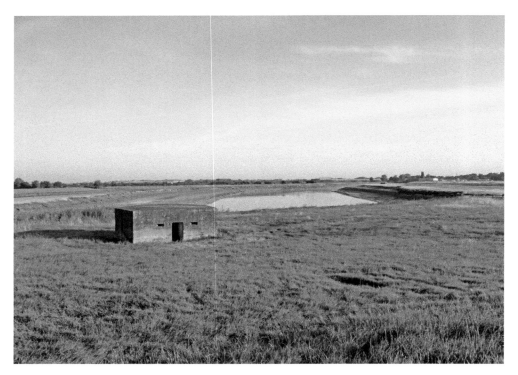

The picturesque setting of a pillbox on the banks of the River Parrett at Bridgwater.

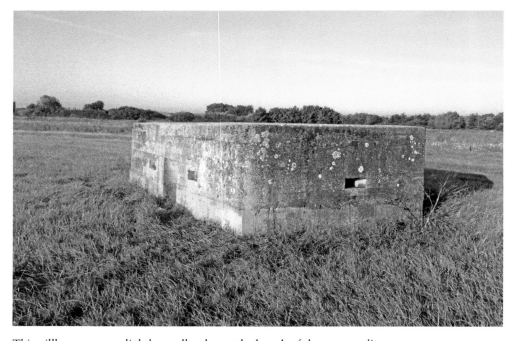

This pillbox appears slightly smaller due to the length of the surrounding grass.

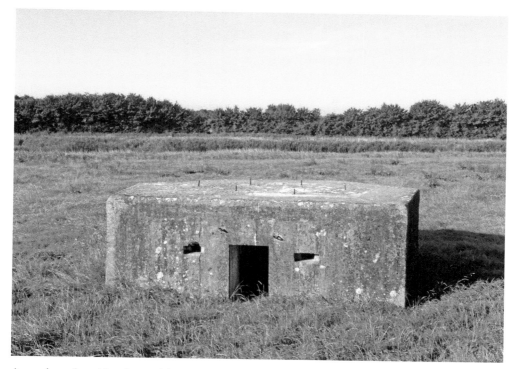

A number of steel hooks used for attaching camouflage over the pillbox are still clearly visible.

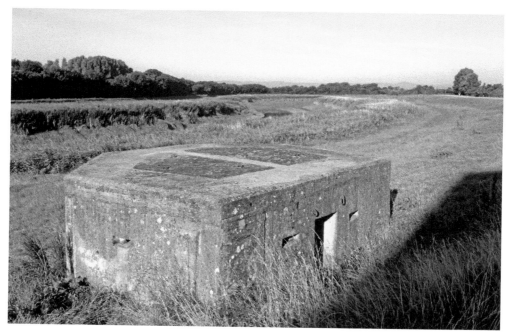

Nestled into the riverbank, a pillbox still stands on duty.

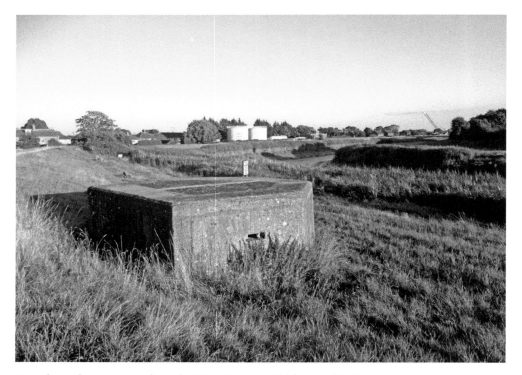

From here, the next stop along the River Parrett is Bridgwater Docks.

the grass around it, but access is still possible. At the next bend in the river, there are two further pillboxes less than 200 metres apart. These both have a vast number of steel hooks and loops visible on top and by the entrance, where camouflage by way of netting or a more elaborate pitched roof would have been attached. From here, Bridgwater Docks are around a mile away.

Bridgwater itself was one of the main 'defensive strongholds' of the Taunton Stop Line. With a population of around 20,000 in 1941, it is no surprise that Bridgwater had its own unit of the Home Guard. Led by Lieutenant-Colonel R. Chamberlain, some 2,500 men were split into platoons that would patrol the various locations and positions of the stop line. Throughout the town, anti-aircraft emplacements and strategically placed pillboxes and roadblocks would have formed a solid base with which to hold up any invasion. The vast majority of the town-based defences have long since gone, with the rebuilding and restructuring of the town over the past decades causing them to be demolished. Two such known pillboxes that once stood at The Clink, for example, were lost in 1982 due to the road developments.

As well as the importance of the docks and train station for the transportation of supplies and people, Bridgwater contributed a lot to the war effort as an industrial centre. The various local manufacturing units that existed in the town began producing a wide range of goods, with the cellophane plant leading the way by producing a protective film that could be used to encase ammunition and protect it from the heat

and humidity of foreign theatres of war, such as North Africa and East Asia. Shell casings and components for tanks and landing craft were also created in the town.

However, there are a few grand relics near Bridgwater train station that still stand tall today. On the north side of Westonzoyland Road are two pillboxes at either end of the road bridge that straddle the railway track. Standing two-storeys high, they overlook the train station, and there are three anti-tank blocks still in existence just opposite on Loxleigh Avenue. Measuring just over 1 metre in their dimensions, thousands of anti-tank cubes were made out of reinforced concrete and placed to hinder the progress of heavy armour.

The train station at Bridgwater was essential during the war, not just for transporting war resources but for receiving many evacuees from the big cities. In the first week of the war the station saw 6,500 people arrive to be housed in the town, with another 1,000 for the outlying villages. Over the course of the war though, these were not the only visitors from out of town. Air raids were expected and, although Bridgwater received relatively few compared to other industrial centres across the country, a number of incendiary and high explosive bombs were dropped on the town, with some civilian casualties. Later in the war, a German Prisoner of War (POW) camp was established at Colley Lane (now an industrial estate) as well as an Italian POW camp at Goathurst, with the captured men living in fairly good conditions and working on the local farms.

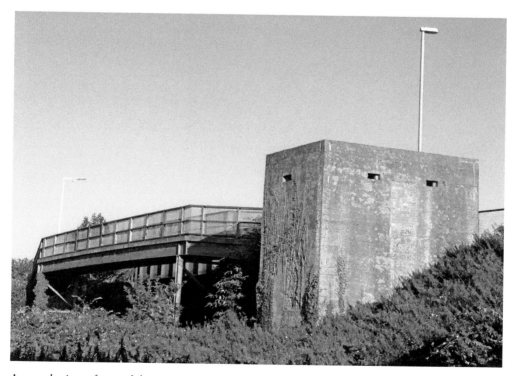

A superb view of one of the two-story pillboxes adjacent to Bridgwater train station.

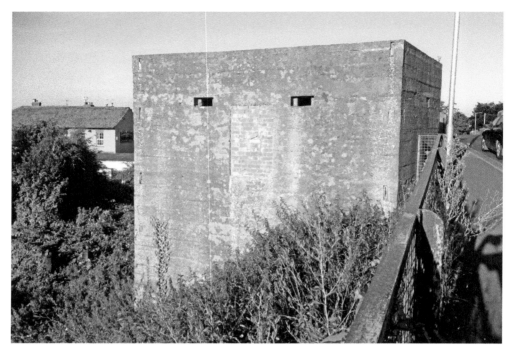

Although now bricked up, the original entrances are clearly visible.

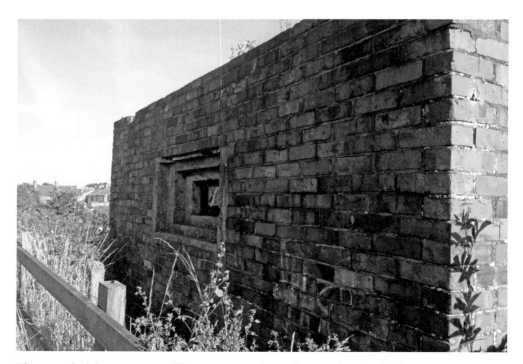

The second of the two-story pillboxes, rectangular in shape and with a brick exterior.

The three anti-tank blocks in Loxleigh Avenue.

Chapter 4

Somerset: The Bridgwater and Taunton Canal

From Bridgwater Docks, the stop line followed the route of the old Bridgwater & Taunton Canal for the next 12 miles or so, sensibly using this man-made structure as part of the defences. Originally opened in 1827, the canal links the River Parrett to the River Tone. Pillboxes were placed at strategic points along the canal, often at turns, where their location would give them the element of surprise over any potential enemies coming around the corner. At over 12 feet wide (3.5 metres),

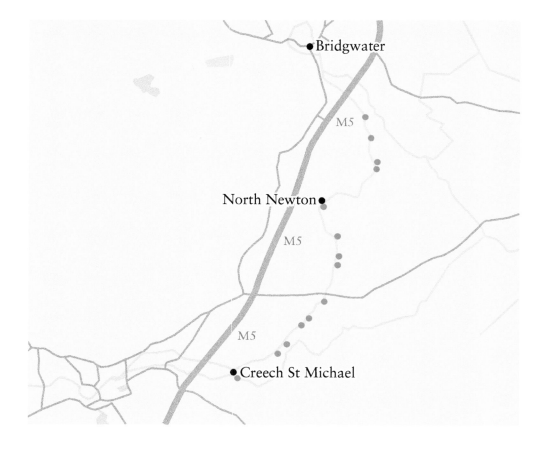

the canal itself would act as an immoveable object that would need to be crossed and, as such, all eleven of the existing brick-built permanent bridges were mined with demolition chambers that would be ignited should they look like being compromised. There were also twelve or so swing bridges (originally constructed as 'accommodation bridges', providing farms with a right of access to their land divided by the canal) that were removed and replaced with simple fixed timber bridges at towpath level.

Heading out from Bridgwater, the stop line follows the canal towards Huntworth, where a pillbox can be found on the canal path. Its front has been ripped out, possibly in an attempt to widen the footpath after the war, but it is clear that the site was chosen to provide cover on the nearby bridge, around 150 metres away. The bridge itself would have been a major point to control, providing access over the body of water that lay beneath, and today there are still four visible demolition chambers that would have been mined with explosives during the war. The local Home Guard unit would have been under orders to blow up the bridge had it looked like an invading force was about to take control of it.

Less than 500 metres further on lies a brick-clad pillbox that protrudes slightly into the canal. Rectangular in shape, and now covered in graffiti, access into the extremely dark interior is still possible, although the inside is sadly littered with rubbish. Adjacent to the pillbox, on the other riverbank, are a number of anti-tank pyramids that stand on a concrete base, jutting out into the canal. These are best viewed during the autumn and winter months as the surrounding plant life will be at their lowest height. Another brick-shuttered pillbox lies at the next bend in the river, although it is well camouflaged by the ivy that is now growing on it.

After the bend the canal towpath approaches the small village of Fordgate, where two emplacements are situated either side of small bridge. The first, around 50 metres from the bridge, juts out from the extra protection of the verge but is only around half the height of the others as it has been built down into the canal towpath – the gun loophole is only a few inches off the floor. Its concrete shell was once covered in brick but the vast majority of this shuttering has now gone, with only five layers of brick remaining. The second emplacement, 100 metres on from the bridge, is located in the hedgerow and cloaked in ivy, with only one side noticeable.

There is now a long stretch of over 2 miles from Fordgate to North Newton where there is only one pillbox. Located at a sharp bend in the canal, and barely visible due to the tree coverage, it is at the end of farm buildings and appears to be quite high above the level of the canal.

Just after the permanent bridge over the waterway at the east end of the village of North Newton, the canal turns sharply and heads in a southward direction again. From this bridge, two heavy machine-gun emplacements, 20 metres apart and complete with blast walls at the entrance to protect those inside, can be seen in the farmer's fields around 200 metres away. They are actually only 10 metres from the canal itself, but the foliage in between has grown to such an extent that they cannot be seen from the canal path. A hundred metres further on, an unmissable pillbox sits prominently at the side of the canal, now with a bench on one side to take a well-deserved break.

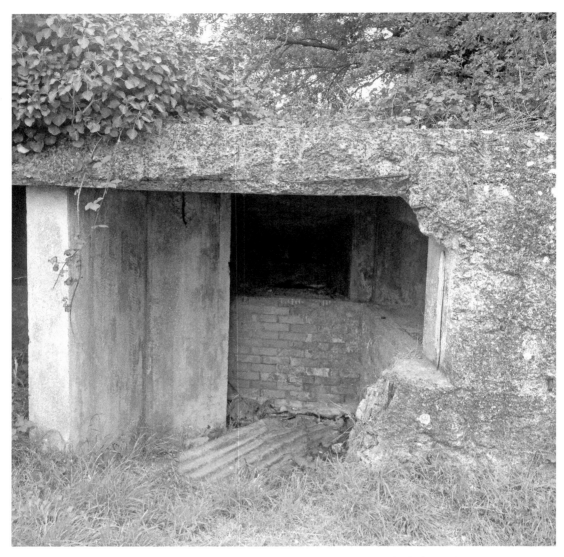

An excellent opportunity to see inside a pillbox and realise just how thick the walls are!

There was once a bridge crossing the canal at this point, which explains the location of this pillbox, but only the footings remain among the undergrowth.

The canal continues for approximately a mile before it reaches the Maunsel Lock Canal Centre. On the approach to the centre, and within sight of the bridge, there is a small clearing in the hedgerow that reveals a muddy bank with a pillbox at the top. The scramble up is worth it as there is a good condition heavy machine-gun emplacement just waiting to be explored. Complete with a blast wall at the entrance, it would have had an outstanding field of vision along the canal and overlooking the road bridge, although the trees and plants have now obscured this over the last three-quarters of a

The demolition chambers under the Huntworth Lane Bridge are still clearly visible, after they were filled with concrete and bricks after the war.

century. Such a heavy machine-gun emplacement would have likely stationed a Vickers machine gun, which required at least one man to fire and another to feed in the long cloth belts into which the rounds had been placed by hand. The gun itself was just over a metre in length and weighed a minimum of 10 kilograms (depending on the gear attached). It would have sat on a tripod (itself weighing in at around 20 kilograms) and could have fired between 450 and 600 rounds per minute. The gun used a water-cooling system to prevent overheating, but the barrel of the gun would still have needed changing every hour and, with the weight and size of the spare ammunition and

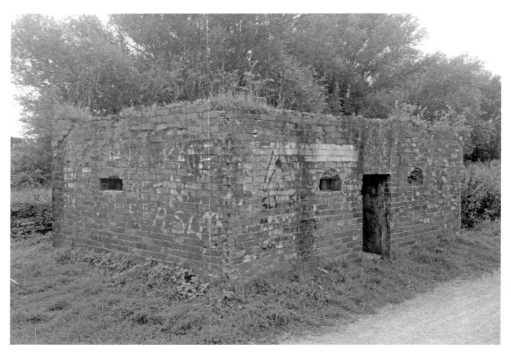

An easily accessible rectangular pillbox on the Bridgwater & Taunton Canal towpath.

Covered in ivy, only the front of a pillbox is visible further along the path.

The small village of Fordgate has a pillbox either side of its bridge.

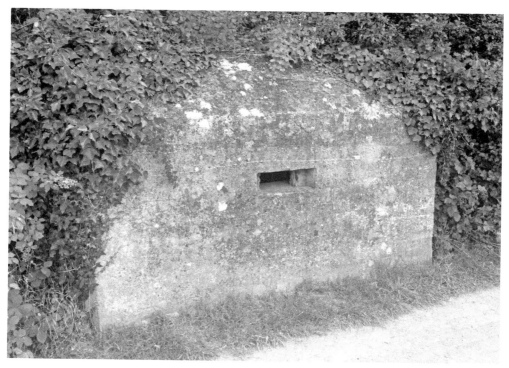

The chamfered roof of the second emplacement at Fordgate is visible.

parts, it's likely a six- to eight-man team would have been based here. The Vickers gun was known for its reliability and with a range of up to 4,000 metres this emplacement would have easily covered the road bridge less than 100 metres away.

From Maunsel Lock it is a short walk to Stausland Lock (also known as Higher Maunsel Lock) where just to the south is a brick-clad pillbox sat on the roadside, partly covered by the hedge of the field. Further along the path there is a partially destroyed pillbox that has had its front completely removed – most probably to allow better access along the canal towpath. As a result, you are able to fully appreciate the sheer thickness of the shellproof walls and roof, as well as get a sense of the space created on the inside for the soldiers by the embrasures. It stands in a very exposed part of the canal, with minimal hedge line for protection and vast open fields on both banks. It is easy to go inside and, when looking out from the entrance way, it is reasonable to assume that those stationed here would have needed a ladder to access it.

A mile further on, the canal passes under the A361 road, which is almost equidistant between the villages of Durston and West Lyng. Within this area there are a number of pillboxes, anti-tank obstacles and light and heavy machine-gun emplacements that

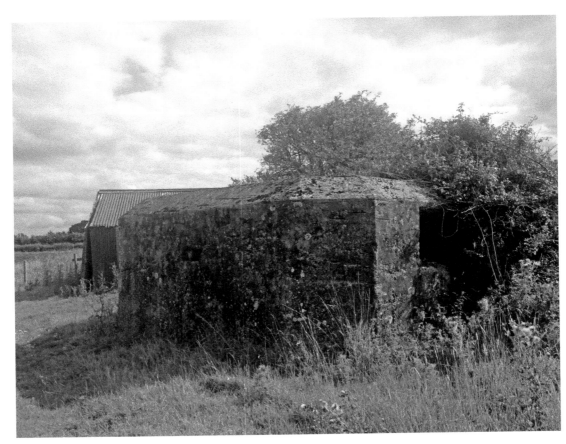

The massive opening for the heavy machine gun is just visible.

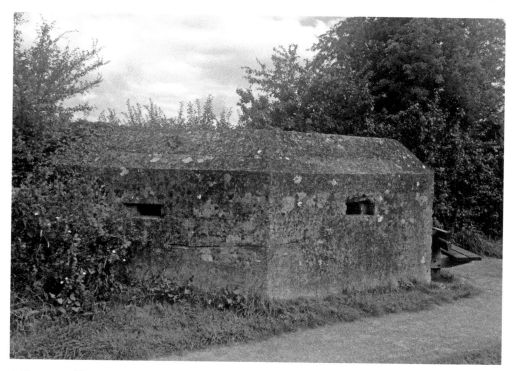

A Type 24 pillbox just south of the village of North Newton.

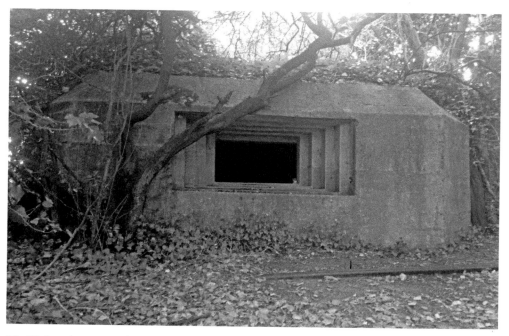

The Vickers heavy-machine-gun emplacement overlooking Maunsel Lock.

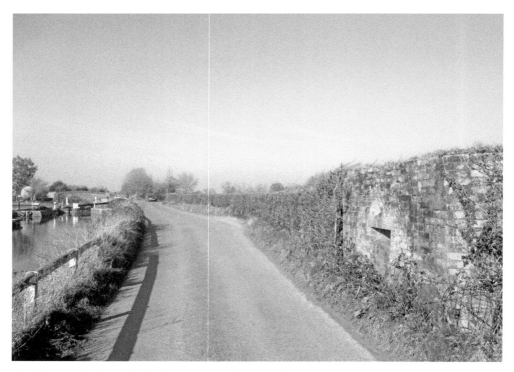

A pillbox nestled into the hedging just south of Stausland Lock.

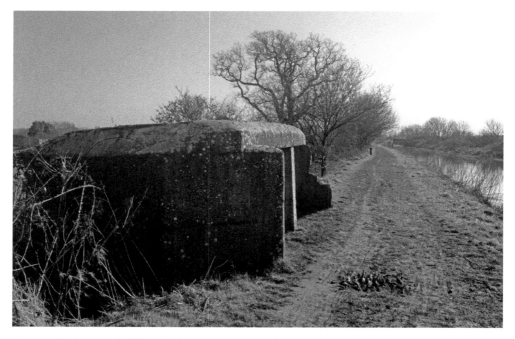

A partially destroyed pillbox facing out to the canal.

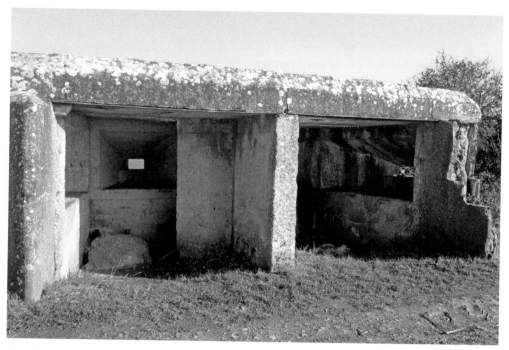

The thickness of the walls and roof are easily seen.

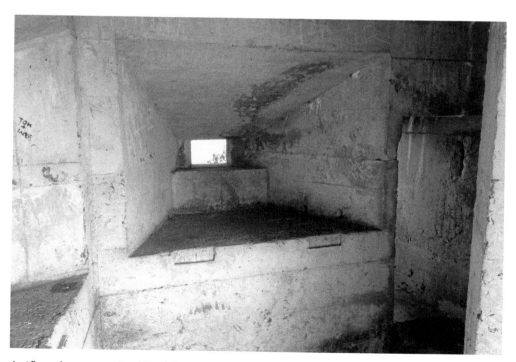

A rifle embrasure to the side of the entranceway, with room for those inside to steady themselves.

The thick, reinforced shellproof wall of the pillbox.

formed the Durston Anti-Tank Island – the second of the twelve defensive islands along the stop line. The defences here cover the Cogload railway junction, named after the nearby Cogload Farm, which is a significant part of Somerset's infrastructure where the original rail track to Bristol is joined by the Penzance–London line. The structures aren't visible from the canal, and access to them is obviously difficult due to the vast majority being on or around a still-active train track.

From here, a leisurely stroll on the canal path for a further mile or so, which has the railway as company, brings you to a wonderfully positioned pillbox, which was no doubt deliberately placed for its proximity to both the canal and the rail track, which is no more than 25 metres away.

The small village of Charlton, little over a mile away downstream, has three protective structures: a thick-walled pillbox located to the north, demolition charges under the bridge that carries Charlton Road, and a pillbox standing alone, positioned overlooking the bridge at the crossroads with Foxhole Lane.

On the outskirts of Creech St Michael is 'The Old Engine House', which was used to pump water from the nearby River Tone into the canal; a pillbox was built right outside it in order to defend the pump house from attack.

Creech St Michael itself was the third so-called 'defensive island' due to the fact the Bridgwater & Taunton Canal and the River Tone pass within 200 metres of each other at the centre of the village. As a result, Creech St Michael had a number of anti-tank defences positioned by the two waterways and the railway tracks in the hope that they, together with the Home Guard unit, would be able to defend the southern part of the village. The St Michael Road bridge in the middle of the village, which carries St Michael Road over the canal, still has its demolition chambers (now blocked up) clearly visible. Heading out to the west of the village on the canal towpath there is a large rectangular pillbox, which seems to be a variant on the Type 26 design. Each wall is around 2.5–3 metres in length and, according to the design features, it wouldn't have had an internal wall. The doorway is blocked up and, although it is overgrown, you can see that the walls are, unusually, constructed mainly of brick. This location would have allowed the Home Guard stationed here the opportunity to protect the canal and the River Tone. There are a number of pillboxes located along the railway track that are visible on maps and satellite images of the area but are inaccessible to anyone on

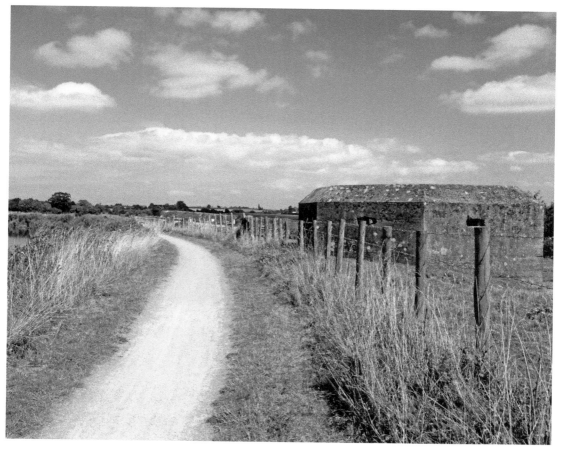

A pillbox strategically placed between the canal and rail track.

foot. At Lipe Lane, along the site of the old Taunton & Chard Canal, you can see a pillbox in the middle of a farmer's field and there are records of two being built into the nearby tunnel. Heading east out of the village, where Bull Street meets the public footpath along the north bank of the River Tone, there is a pillbox in good condition, although its doorway and gun loophole are concreted up.

Within 5 miles of Creech St Michael lies Walford House and its vast grounds, which after the threat of invasion from Nazi Germany became a large tented military camp for hundreds of American troops in late 1942. They remained there until just before the D-Day landings of June 1944, and it is said that, when they left, their convoy stretched from Walford Cross to Henlade – a distance of some 4 miles. After this, Italian Prisoners of War were held within the grounds until around 1945 when they were replaced with German Prisoners of War. Both sets of POWs were taken each day to help construct the Kings Sedgemoor Drain just north of Bridgwater. Originally constructed to help drain the Somerset Levels, it was significantly upgraded using the POW labour during the Second World War to provide a backup water supply for the armaments factory at ROF Bridgwater, which required a staggering 4.5-million gallons of water a day.

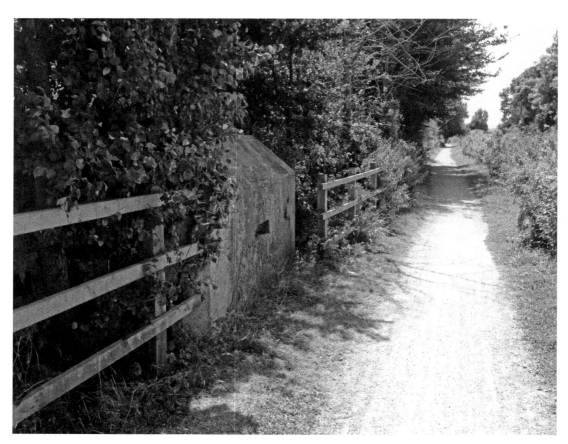

Located to the north of the village of Charlton, a pillbox can be found along the footpath.

The demolition chambers under the bridge at Charlton are now blocked up.

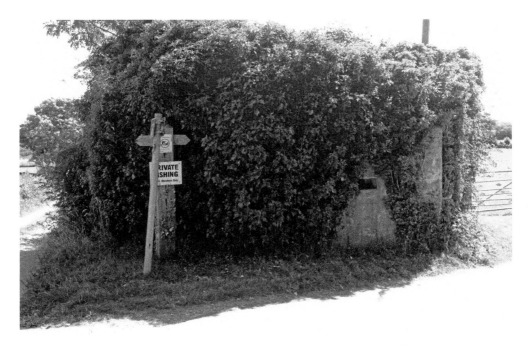

Now overgrown with foliage, the pillbox on Foxhole Lane is only just visible.

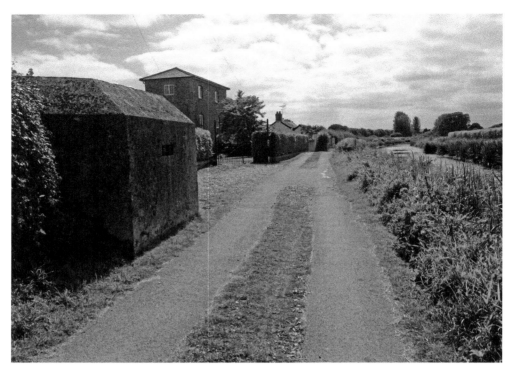

The Pump House on the outskirts of Creech St Michael was defended by a pillbox.

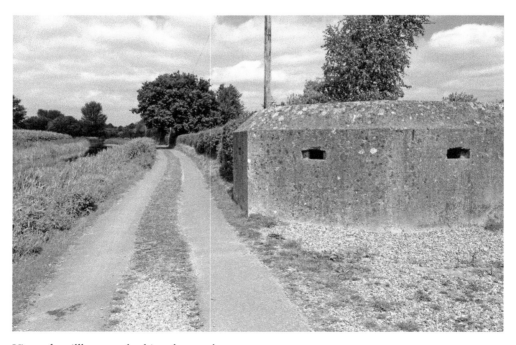

View of a pillbox overlooking the canal.

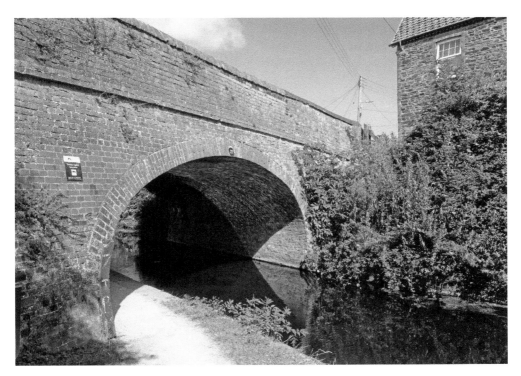

The main road in Creech St Michael crosses over the Bridgwater & Taunton Canal.

Although now blocked up, the demolition chambers under the bridge are clearly visible.

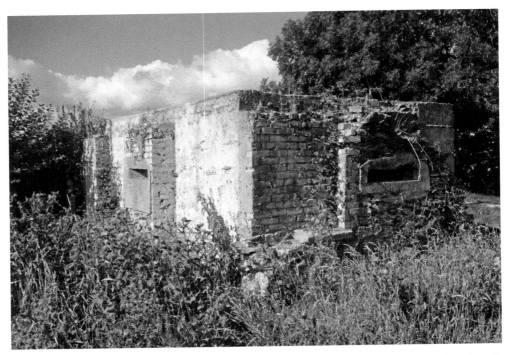

The uncommon Type 26 pillbox located along the Bridgwater & Taunton Canal at Creech St Michael.

A pillbox with an information board overlooking the north bank of the River Tone in Creech St Michael.

Chapter 5

Somerset: Wrantage to Ilminster

From the small village of Creech St Michael, the footprint of the Taunton Stop Line follows the line of the old dried-up bed of the Taunton & Chard Canal. Originally completed in 1842, the 13.5-mile canal weaved its way through the Somerset countryside, passing over four aqueducts and through three purpose-built tunnels. However, due to the competition posed by the railways, the canal was never economically viable for the company that owned it and was eventually closed in 1868.

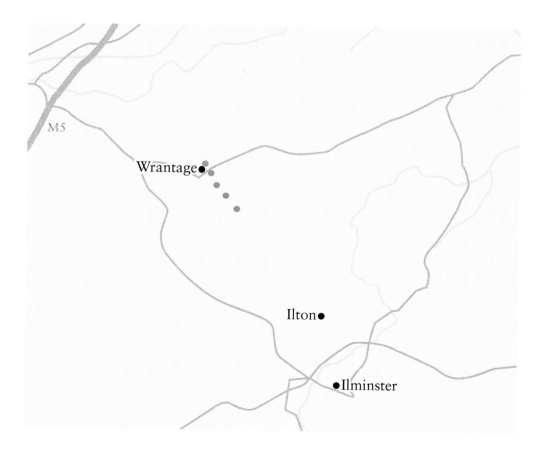

The canal and its structures stood neglected and largely untouched for over seventy years until it was then incorporated as part of the Taunton Stop Line.

From Creech St Michael the stop line followed the canal along the outskirts of Thornfalcon and up to the 400-metre Lillesdon Tunnel. There are a few pillboxes scattered along this route, especially near the tunnel entrances, although the vast majority of these are completely overgrown or currently sit on private farmland and are therefore inaccessible.

From here, the canal bed makes its way towards the tiny village of Wrantage, which was the fourth of the so-called 'anti-tank islands'. On the main road there is a pub called The Canal Inn, which, as the name suggests, was alongside the route of the old canal at one point. A small 3-metre section of an anti-tank wall is still standing and on the old canal embankment behind the pub stands a Type 24 pillbox in an elevated position overlooking the area. Across the road in Higher Wrantage Farm, a pillbox sits on top of the old canal bank in what is now a farmyard, and in the adjoining field another structure can be clearly seen.

From here there is a public footpath up a farm access lane that takes you towards Crimson Hill. At the top of the lane, the footpath becomes narrower and steeper as you head up towards the entrance of the Crimson Hill Tunnel. Built as part of the Taunton & Chard Canal, it is one of the longest tunnels in the country, spanning a distance of over 1,500 metres. During the war the tunnel is said to have been used for the storage of armaments, specifically mines, and as you approach the entrance there are a number of anti-tank cubes dotted around. However, the tunnel itself is partly submerged in water and silt, so entry would need to be taken with extreme caution. The footpath continues for a few more metres and brings you to a clearing that shows you a rather steep hike to the top. Halfway up though, if you veer off to the right, there is a pillbox nestled into the hillside. Soil has piled up behind it and access is impossible, but the views offered, although now blocked by the treeline, make the choice of location understandable and it is suitable motivation to continue the trek to the top to see the structures there! After negotiating some fairly steep steps to the top, you find yourself confronted with two Vickers machine-gun casemates. The first is roped off and in danger of being lost to the surrounding vegetation; however, the second one is sat proudly dug into the top of the hill and in good condition. With walls over 4 metres in length, this was certainly a structure built to last. There is a freestanding blast wall covering the entrance on the left-hand side and inside there are no internal walls. The view from this pillbox is simply stunning and must stretch on for miles and miles – a nice spot for a rest and a picnic!

The old canal bed ran in a south-easterly direction from Crimson Hill across the vast open fields of farmland around Curry Mallet. Along the way a few pillboxes were erected in fields and some can just be made out today, but between here and the next main part of the stop line at Ilton emplacements are few and far between. A closer inspection of a map of Somerset possibly reveals why.

To the north of the village is an aerodrome, which itself would have obviously had a large range of defences that would have been part of the Taunton Stop Line. No doubt plans were already in place for the building of the aerodrome when the

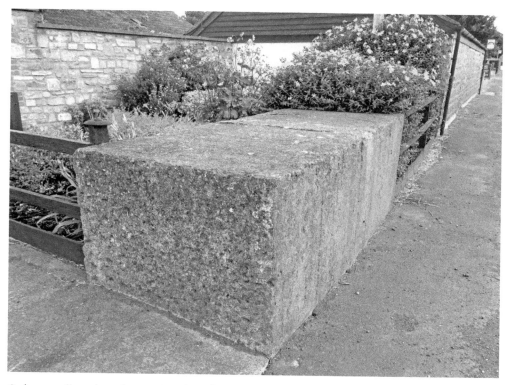

Only a small section of an anti-tank wall remains along the A378 at Wrantage.

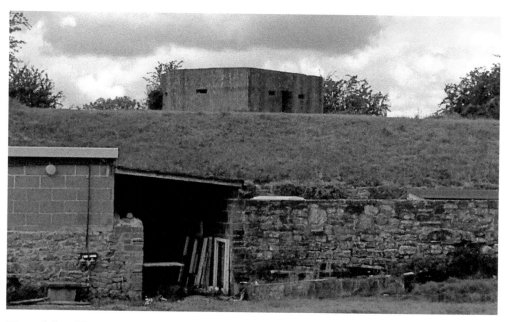

View of the pillbox on the old canal embankment at Wrantage, near the pub.

A row of anti-tank cubes on the incline towards the entrance of the Crimson Hill Tunnel.

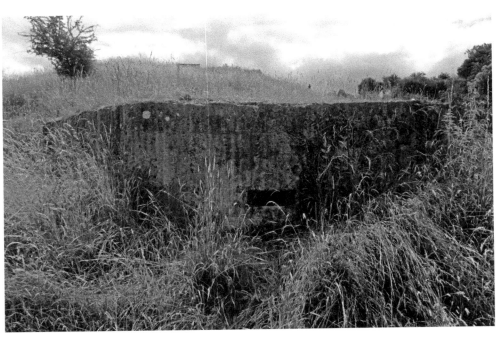

A pillbox halfway up Crimson Hill, now almost completely overgrown.

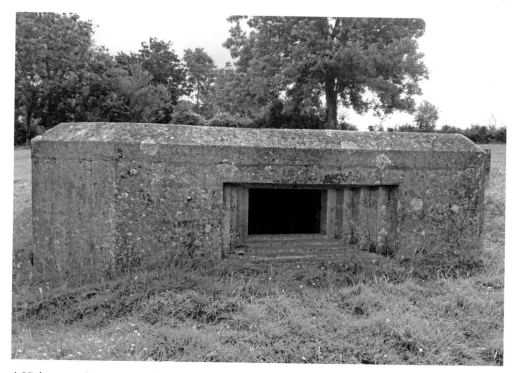

A Vickers machine-gun emplacement atop Crimson Hill, with its massive gun embrasure.

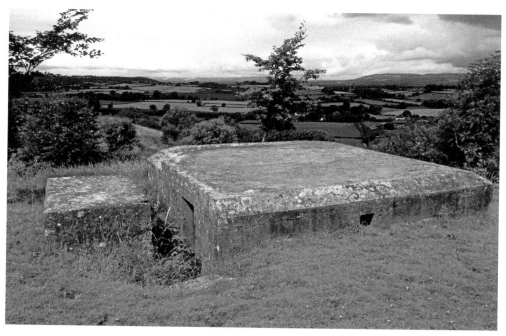

There is a stunning view stretching on for miles and miles.

stop line was created, which goes some way to explaining the lack of pillboxes over the 2 miles between Ilton and Curry Mallet, but construction of the airfield wasn't initiated until the second half of 1942 when the vast estate of Merryfield was chosen. Originally named RAF Isle Abbotts after the small village to the north, work began to create a Class A airfield, namely one that would be suitable for use by heavy bombers. Overcoming the drainage issues related to building anything on the Somerset Levels would have certainly hindered the work, and it would be a good eighteen months before the airfield was ready to be used. In 1943 the airfield's name was changed to RAF Merryfield, and in February 1944 it was officially opened by the Royal Air Force. The airfield comprised of three concrete runways – the shortest of which was around 1,000 metres in length and the longest being well over 1,750 metres – as well as all the associated support buildings required. Almost immediately, the airfield was handed over to the United States Army Air Force to facilitate the movement of US troops during the final years of the conflict, which resulted in RAF Merryfield becoming known as USAAF Station AAF-464. By April 1944 the 441st Troop Carrier Group arrived with no less than seventy Douglas C-47 Skytrain military transport aircraft, which were capable of carrying approximately twenty-eight personnel or nearly 3,000 kg in payload. US engineers improved the facilities to allow gliders to be used and further accommodation was created to house the hundreds of paratroopers that were to be stationed there. Activity in the area must have been constant from spring 1944 onwards, as the various members of the 442st Troop Carrier Group trained in preparation for Operation Overlord – the liberation of France. As part of IX Troop Carrier Command, there would have been a lot of night training for the pilots and no doubt practice jumps with the airborne paratrooper divisions that were with them.

During the evening of 5 June 1944, planes from here set off for the Normandy coastline with the elite pathfinders (target marking troops) and paratroopers destined to play their part in the D-Day landings. One of the most extraordinary moments of the D-Day landings involved US paratrooper Private John Steele, who as part of the 501st Parachute Infantry Regiment embarked from RAF Merryfield heading for their designated drop zones near the town of Sainte-Mère-Église in north-west Normandy. Private Steele unfortunately landed on the pinnacle of the church tower in the town square, where he had to hang for over two hours pretending to be dead! The Germans took him prisoner but he later escaped and rejoined his division as they attacked the occupying forces, and Sainte-Mère-Église became the first village in Normandy to be liberated by the United States Army on D-Day. In all, some 24,000 American, British and Canadian airborne troops landed behind enemy lines shortly after midnight, of which some 1,400 flew from RAF Merryfield in what turned out to be one of the most decisive moments of the conflict. For the next few days the airfield would have been a hive of activity. The planes returned from their initial mission to pick up their quota of some of nearly 4,000 gliders that were sent across the English Channel during the day of 6 June, delivering more troops and, crucially, a selection of field units such as anti-tank guns and artillery for the men behind enemy lines. For the next five months, supply missions would have been constantly taking off from the very heart of the Somerset Levels, delivering personnel, armaments and provisions, and a medical

reception area was established at the airfield in order to process wounded soldiers. On 6 September 1944 the carrier group were relocated to Villeneuve in France due to the significant advances made by the Allied forces, but the airfield didn't revert back to RAF control until October. The airfield is currently occupied by the Royal Navy, where it is used as a training facility for helicopter pilots. As it is still an operational site, photography is restricted at RNAS Merryfield.

The village of Ilton, just 1 mile to the south of the airfield, was one of the designated anti-tank islands and would certainly have had a vital role to play in defending the airstrip. The majority of stop line defences here are to the south of the village, with a range of anti-tank cubes and ditches, roadblocks and pillboxes being built. Nearly all of these structures are located on, or very close to, the disused Great Western Railway embankment, which was originally built in the 1860s as a means of connecting Chard and Taunton. The next stop along that route is the town of Ilminster, which, although fortified as part of the stop line, now has few remnants due to its urban development over the last seventy years.

Chapter 6

Somerset: Donyatt to South Chard

From Ilminster, the stop line continued to run along the disused railway embankment, where a few pillboxes can be identified in farmland before reaching the tiny village of Donyatt.

For such a small village – less than 350 people – it is perhaps surprising that it once had a small station, but the now idle Donyatt Halt has a large number of wartime relics surrounding it. Originally built in 1928, Donyatt Halt comprised of a single

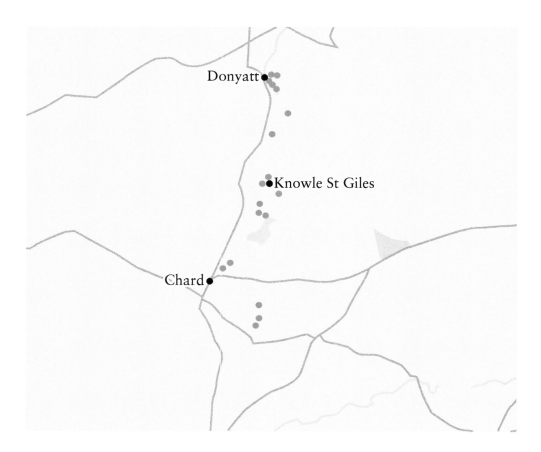

platform and would most probably have been used as an inspection point during the war to stop and check any trains using the lines between Chard and Ilminster. By 1964 it had closed and it is thanks to the work of the volunteers of 'The Stop Line Way' who cleared and created the cycle track that ultimately allowed the station and its wartime neighbours to emerge from the decades of undergrowth.

The bridge over the railway line would have been primed for demolition and, after crossing, to the left at the top of the cutting, there are some anti-tank concrete posts along with a large concrete block that would have formed a roadblock with the aim of stopping tanks moving eastwards. From here it is possible to walk down to the platform via a small path that runs past an impressive row of sixteen anti-tank cubes, although this route does get quickly overgrown throughout the year so the easier option is to take the path just prior to crossing the bridge. The anti-tank cubes are easily visible and following them along the embankment you come to an anti-tank railway block, which would have aimed to stop tanks crossing via the railway. Continuing along the footpath, past Donyatt Bowling Club, there is another set of concrete roadblocks at the end of a small bridge over the River Isle. These railway (and road) blocks stand well over 1 metre high and are more than 50 centimetres wide. They are made of solid concrete and its trapezoid shape allows the base to be more secure, meaning it would hopefully withstand greater impact. They have a large groove running halfway down in which the 'block' itself would have been placed. On the west side of the tracks was a large anti-tank ditch that would have been over 10 feet wide and 6 feet deep, running all the way to Peasmarsh, although this is now largely filled in.

On the day the war broke out the evacuation of children from the large industrial centres began, and Donyatt Halt received a large number of young children escaping the bomb-hit cities. On the platform there is a wooden statue of Doreen Ash, who was actually evacuated to Donyatt during the Second World War, and it stands as a reminder of all those children who arrived in the village. Sadly, recent vandalism has seen this statue burnt to the ground.

Overlooking the station from the north are a number of defences within the grounds of Downs Farm. Heading back up to the bridge, in the middle of the field is a pillbox, now camouflaged by bushes and grass but clearly visible as the only thing in the field – aside from the livestock. Walking along the road brings you to an emplacement for a 6-pounder anti-tank gun, and further along the edge of the field are two pillboxes designed to house the Vickers light machine gun. They are located within 100 metres of each other – as they usually are on the stop line – and each of these are gradually becoming overgrown. However, the front embrasures are still visible and just about accessible. Looking down from this vantage point gives you an excellent view of the halt and track, and gives you a very good insight as to the location of these emplacements.

Heading back down the tracks and passing the anti-tank roadblocks near Donyatt Bowling Club, follow the public foot and cycle path for another 300 metres. The footpath here veers sharply to the left (the disused Taunton–Chard line was replaced with the A358) and then merges with 'Watery Lane'. At this point, there is a pillbox lurking in the depths of the undergrowth but by following the road around you are taken to the small hamlet of 'Sea', where there is a pillbox in good condition on the

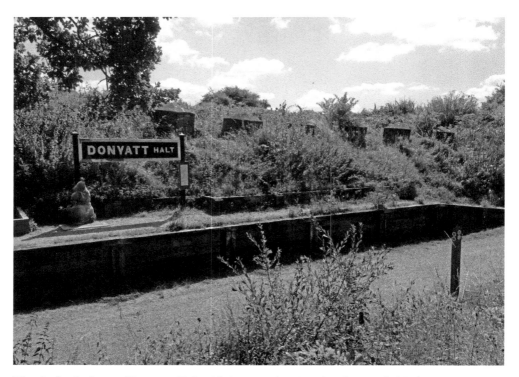

The single platform of Donyatt Halt with its row of anti-tank cubes just behind it.

A pair of huge concrete blocks ready to be used as road blocks within sight of the platform.

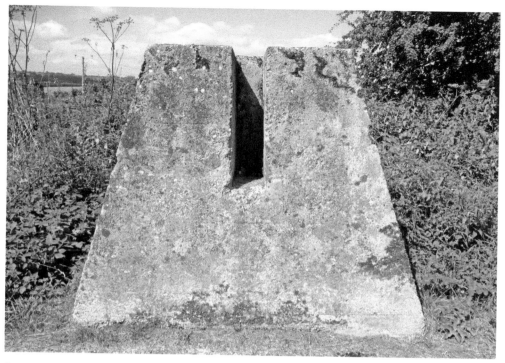

Sections of old railway track would most likely have been inserted to create the barrier.

Overlooking the platform from the road bridge to the north.

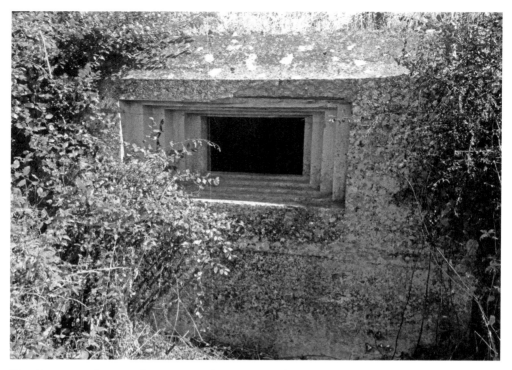

Two Type 24 Vickers machine-gun emplacements are located on the eastern side of the railway.

Another set of roadblocks lie in good condition further along from Donyatt Halt.

east side of the A3037, where there is a sharp bend in the road. It is easily missed as it's well hidden from the A358. The pillbox is still structurally sound, although access is restricted as the entrance is inside the farmer's field. Sticking on Watery Lane as you head south, there is another pillbox hidden behind the hedgerow in a field, just before you get to Peasmarsh Farm. Being the regular Type 24 pillbox, it is made of reinforced concrete and set up facing the busy A358 – the site of a level crossing over the old Taunton–Chard railway line. At this point, the public foot and cycle path reappears just before the main road and the disused track runs a very straight course now for roughly a mile. As you make the leisurely stroll along the flat terrain, the site of the Chard Sewage Treatment Works is to the left, which, according to records, has two more pillboxes within its grounds – obviously out of bounds today. Along the way are the battered remains of a railway blocking point that has seen better days, and, as you enjoy the abundant wildlife, you soon approach your next destination of Knowle St Giles.

Coming into sight first is a road bridge over the path which, as you get closer to it, you can see has two 1 metre anti-tank cubes either side of what would have been the site of the old railway track. There is a very enlightening information board under the bridge too, which helps you get your bearings. Off to the left of the bridge on its north-east corner, following the steps up to the road, there is a significant anti-tank gun emplacement facing in the direction of Peasmarsh. Made of reinforced concrete and over 3 metres in width, the gun emplacement has a sloping roof, which would have housed a massive 6-pounder anti-tank gun that would have been taken from a First World War tank. The 6-pounder Hotchkiss Mark I and II anti-tank gun was a shortened version of the original 6-pounder Hotchkiss naval gun, which had turned out to be too long for practical use with British tank designs. It was redesigned and redeveloped during the First World War for use in the Mark IV and Mark V tanks and had a barrel length of around 1.5 metres, which helps you understand the reason for such a large gun emplacement. From its elevated position above the railway line, it could have easily fired over 500 metres and it is the hardest-hitting emplacement along the Taunton Stop Line. A certain level of expertise was needed to fire it, so it was members of the Royal Artillery and not the local Home Guard who manned it, living in tents and cooking their own food. During the cold winter months, the tents were removed and the soldiers were billeted in the relative luxury of the watermill building a few hundred metres away on the Manor Farm estate. This large gun emplacement is in very good condition, sheltered from the elements by the bridge and the embankment, and is easily accessible. The metal gun-mounting pedestal is still intact and imagining the 6-pounder gun being in place leaves very little room inside for anything else!

Climbing up the steep steps to the bridge where a roadblock was once situated, there are a collection of anti-tank cubes still visible in the hedgerow, despite the best efforts of the ivy to conceal them. Turning left from the steps and continuing along the road for around 100 metres, there is a pillbox in the field to the east of the railway that was once disguised as a chicken house. From this location it would have been able to have covered both the roadblock on the bridge and the railway track with its arch of machine-gun fire.

Knowle St Giles is only a small village of less than 250 people, so it is perhaps unusual for there to be such defensive measures put in place here. However, it is all about location. The village is situated on the River Isle and the road bridge crosses the old Taunton–Chard railway, making it strategically very important. Also, within 2 miles of Knowle St Giles is the small village of Cricket Malherbie, which has the Grade II-listed house Cricket Court. Set in over 5 acres of woodland, during the Second World War the mansion was owned by the press baron and owner of the *Daily Express*, Lord Beaverbrook. Winston Churchill was good friends with Lord Beaverbrook and he was given a number of Cabinet posts during the war years – one of which, during the building of the Taunton Stop Line, was that of Minister of Supply (29 June 1941–4 February 1942). Whether this had any impact on the type of defences build at Knowle St Giles is indeterminable; however, it is entirely probable that a few 'extras' were sneaked into the plans to bolster its defences! As the war progressed and the threat of Nazi invasion subsided, Cricket Court and the surrounding area still had a small role to play, as it was used as a secret meeting place for Prime Minister Winston Churchill and American General Dwight D. Eisenhower, who visited and stayed as guests of Lord Beaverbrook during 1944 while they were planning the D-Day landings.

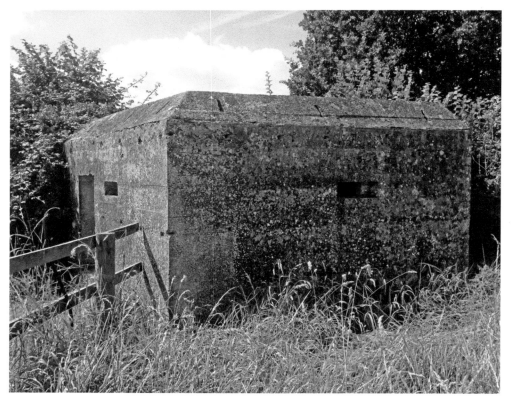

A regular Type 24 pillbox in good condition at the hamlet of Sea.

This railway block near Peasmarsh only has one of its two sections remaining – the other was removed at some point after the war.

Approaching Knowle St Giles from the disused Taunton–Chard railway line gives you a splendid view of the defences around the road bridge, including the gun emplacement to the left of the picture.

Steps leading from the railway track to the road bridge via the 6-pounder anti-tank gun emplacement.

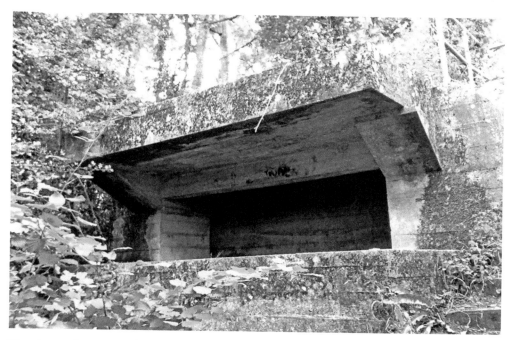

The 6-pounder anti-tank gun emplacement that would have once housed a gun from a First World War tank.

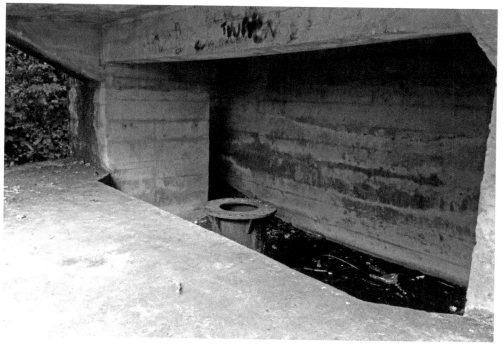

View of inside the emplacement, complete with its metal gun-mounting pedestal.

The steep steps linking the road bridge, gun emplacement, and railway track.

Anti-tank cubes, now camouflaged by ivy, to the side of the bridge.

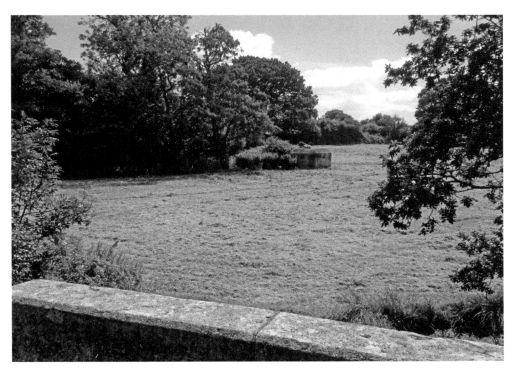

This pillbox covered both the road bridge and railway track with its line of fire.

From Knowle St Giles, the public walk and cycle route continues for around another mile before it reaches the now disused Chard Reservoir. This conservation area is a haven for birds and wildlife, and its protected status has also meant that the static remnants of Britain's defences have also remained intact. As you begin to approach the reservoir, a seemingly never-ending row of well over 500 anti-tank posts appear along the top of the west side of the railway. Any tank trying to make its way up the steep incline of the railway embankment, which would have been slow-going in itself, would have found these concrete posts, deliberately angled at 45 degrees, a significant hindrance to overcome. Further along, the path branches off into two sections: one continuing along the old railway track and the other veering gently off towards the Chard Reservoir. At this point, where the stop line crossed over the railway, a set of anti-tank rail blocks were placed. Still visible, these huge concrete supports had one large slot in order to place a horizontal piece of railway line, and could have been opened or closed within minutes. Surrounding the rail block on the flatter section of ground are a number of anti-tank cubes, some with a flat square top and others with a pointed top.

From here, according to the information board at the site, there is an anti-tank wall close to the road (now overgrown and indistinguishable) and the stop line crossed the road towards the reservoir, where there was once another road block. Less than 10 metres from here, at the entrance to the lane towards the old mill, there is a pillbox that is rapidly being covered in ivy, although it can still be identified.

At this point, the route of the stop line ran south along the shore of Chard Reservoir, before continuing towards Chard itself, back along the old railway route.

During the war, the vast majority of beaches along the south coast of Britain were out of bounds to the public as they were barricaded with miles upon miles of barbed wire. With petrol also in short supply and unavailable to the public for leisure and pleasure use, a lido was created on Chard Reservoir. With a whole host of sporting events taking place, the residents within the surrounding area were still able to 'get away from it all' and relax at the lido. They were not the only ones either, as American soldiers stationed at the Furzehill (sometimes referred to as Furnham) US Army Camp in Chard also used the lido for recreational activities.

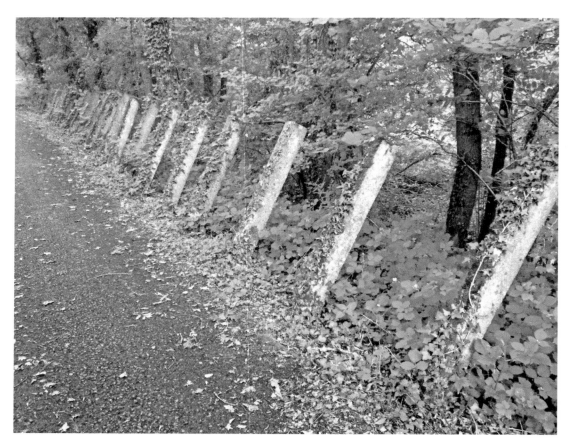

Above: Concrete anti-tank posts line the route of the old railway embankment from Knowle St Giles to Chard Reservoir.

Opposite above: Placed along the side of the old railway track, the anti-tank posts are deliberately angled to hinder any vehicles attempting to climb up the embankment.

Opposite below: The rail block near Chard Reservoir has a slot that would have seen an old railway sleeper used to create a barrier.

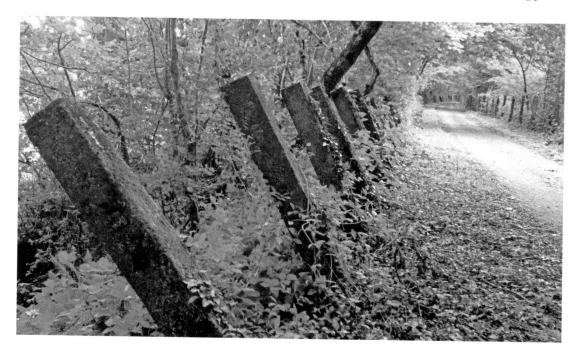

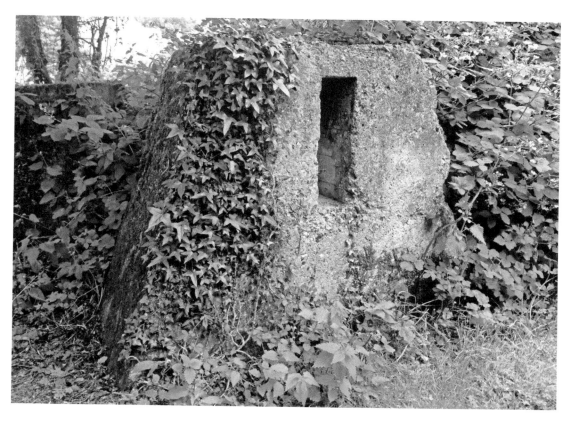

Above: A pillbox, almost completely overgrown, at the northernmost part of Chard Reservoir.

Opposite above: Anti-tank cubes made of reinforced concrete.

Opposite below: The collection of anti-tank cubes and rail blocks near Chard Reservoir.

With the reservoir to the north, Chard, the southernmost town in Somerset with a population of around 11,000 during the war, was the next part of the Taunton Stop Line and was one of the defensive anti-tank islands that had a myriad of obstacles and pillboxes.

Lauded as the 'birthplace of powered flight', where John Stringfellow had demonstrated that engine-powered flight was possible way back in 1848, it was from these beginnings in Chard that Percy and Ernist Petter formed Westland Aircraft

Works a few miles away at Yeovil, which helped produce, among others, Supermarine Spitfires during the war. As with all towns across the country, industry of whatever size was given over to the war effort and Chard would have been no different. In the Furnham and Furzehill area of town in the north, from 1940 onwards it was occupied by the US Army 12th Field Workshop, and throughout the town, defences and pillboxes would have been established at all major routes in and out of the town. Like most of the larger towns along the stop line, the vast majority of structures built have been lost with re-urbanisation after the war. There are no traces of the US camp in the now-residential areas of Furzehill and Furnham Road. Though there are a few structures to be found standing. The stop line ran into the northern part of Chard along the final section of the disused railway track and it is here, adjacent to the old site of the US Army camp a few streets away at Furzehill, that they can be found. On the quiet residential street of Victoria Avenue, and probably passed by hundreds of people every day who don't bat an eyelid at it, there is a low, but very thick, anti-tank wall screened from the road by a hedge. Big enough to stop a 50-ton tank from gaining entry to the nearby area, the wall is split into two sections, with each part being around 3.5 metres wide and 1.5 metres deep. Just around the corner in the treeline by Henson Park, there is a pillbox half buried in the field. Post-war, the area around here must have changed significantly, as up to half the pillbox is now below ground level, with the old entrance way concreted up.

By taking the small trip across this residential estate to the eastern side of chard, there is a pillbox in good condition waiting to be found just off Oaklands Avenue, and by joining onto Crewkerne Road and heading out of town there are two pillboxes just visible – one on either side of the road – although they appear to be on private land and there is nowhere safe to stop and look at them. Back in town and on the industrial estate that is just off Tapstone Road, there are records of a pillbox, but there is no evidence of this from any public footpath.

It is also interesting to note that the branch of the Westminster Bank in Chard had a bomb-proof bunker, which was used to store duplicate copies of the bank's records from its head office in London, as well as the Bank of England's emergency banknote supply.

Continuing out of Chard along the A30 Crewkerne Road, there is a dirt track around half a mile from Chard heading south known as 'The Drift'. This track was originally constructed in the nineteenth century to give the local farmers better access to their fields and, while it is accessible by car, it is probably more advisable to venture down it on foot, especially if there has been recent rainfall as it can get muddy. After a pleasant walk for nearly 2 miles across bumpy terrain, you eventually come across a Type 24 pillbox in good condition, which would have had both Bren light machine guns and Vickers heavy machine guns. Two hundred metres further on, The Drift meets the busy B3162 and, around this crossroads, there are a number of emplacements hidden in and around the woodland area to the east of the village of Forton.

Forton and Perry Street was another of the so-called anti-tank islands created along the stop line with a number of defences concentrated in one area, making it a stronghold. This anti-tank island was slightly more stretched than others and, rather

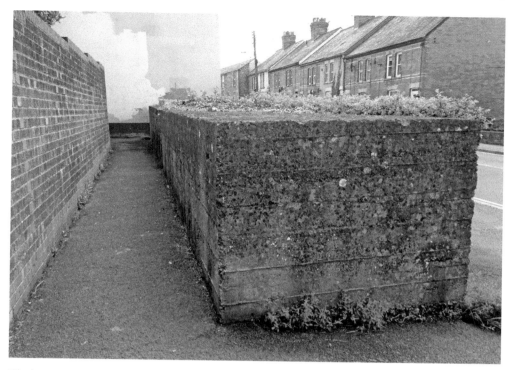

The large anti-tank wall, over 7 metres in length, hidden in plain sight on Victoria Avenue, Chard.

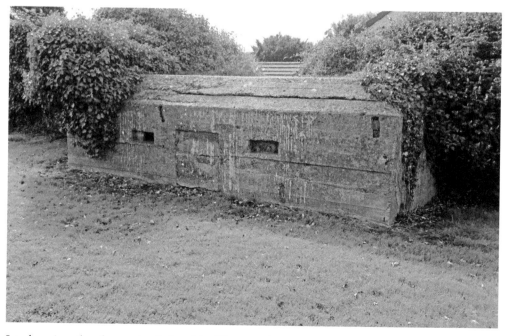

Landscaping after the war has led to this pillbox in Chard appearing a lot shorter than it actually is.

than being based around a population centre, it occupies the space from Forton via Perry Street to the area north of Chard Junction – the site of a major railway terminal.

To the east of Forton, the old railway line ran through a heavily wooded area, which obviously made it the perfect place to build pillboxes – where the local Home Guard would have the advantage of knowing the area and the difficult terrain.

While on the B3162, in an easterly direction and just along from the crossroad with The Drift, there is a pillbox visible from the road. Partially hidden by a tree, it sits in good condition on private woodland. In the opposite direction towards the village of Forton, but before you get to Blacklands Lane, there are a few pillboxes in the woodland. A thick-walled emplacement sits 100 metres north of the main road, positioned to cover the old railway line and the road bridge. Two hundred metres further along the disused railway line there is a pillbox to be found at the now derelict, single-platformed Forton Railway Station. Just off the B3162, only 150 metres along the Forton to White Gate Road, there is a variant on the Type 24 pillbox on the north side of the road, situated at the edge of Horn Moor. Still in very good condition and with thick walls, it has a larger than normal front-wall embrasure (double the size) that faces the road and would allow covering fire from a light machine gun. It still has its hinged metal shutter in situ, and access to the pillbox is possible by walking around to the rear of the structure. In doing so, it is easy to notice that the back of the pillbox has been built up with earth and appears a good 2 feet smaller than the front. There is a steep step down into the inside and it is incredibly dark – a combination of the narrow loop holes, the internal supporting wall and the huge trees that surround it and block out the sunlight. From here, it is a short walk to the next pillbox by following the path through Horn Moor or, alternatively, head back to the main road and along a few metres to The Drift where a small muddy walk leads you to another structure right on the side of the public bridleway. Similar in design and structure to the previous one, although not double storied, this pillbox is still accessible, although the entranceway at the back of the structure is a good 2 feet off the ground. On closer inspection, there appears to be two concrete steps behind the pillbox in a ditch, which at some point must have come away from the main structure. Around the structure, there are a number of other large concrete objects scattered around, some of which appear to be anti-tank cubes and others have grooves carved into them, which indicate they may have been road blocks. Following The Drift back down and across the main road, there are some anti-tank cubes scattered either side of the road – presumably where a roadblock would have also been.

The quality of the pillboxes here, in combination with the woodland and man-made railway embankment, would have made this a difficult area for an invasion force to overcome easily.

From these structures on Horn Moor it is only a five-minute walk back up to the B3162, where you head west to Blacklands Lane, which follows the route of the old railway line and is where the stop line continues. At this point there are some brick remains of the now-dismantled Forton rail bridge before you head down the half mile or so to Blacklands Lane. As you walk down there are a large number of anti-tank cubes spread out on either side, in varying degrees of condition, ranging from easy

The steel visors are still in place on this pillbox located to the north of the B3162 on The Drift.

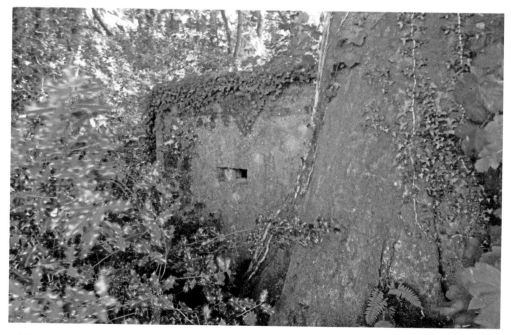

Although partially obscured by a tree, the large Bren gun loopholes are still visible.

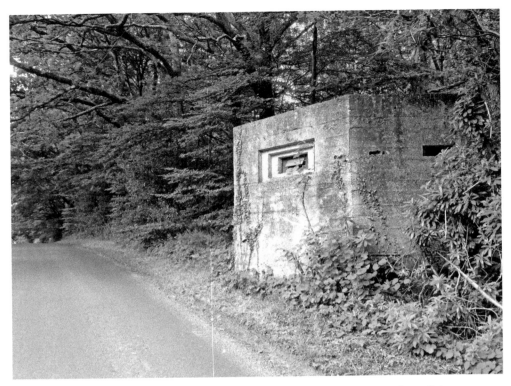

The double-storied pillbox on the Forton to White Gate road is in very good condition.

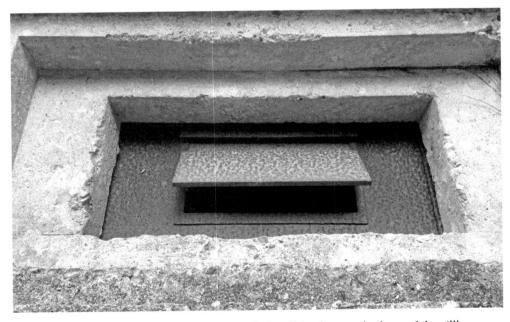

The hinged metal shutter, which opens outwards, is still in place on the front of the pillbox.

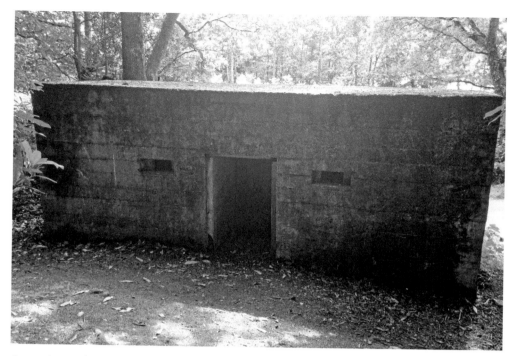

Access is easy but it is incredibly dark inside thanks to the small loopholes and the surrounding trees blocking the light.

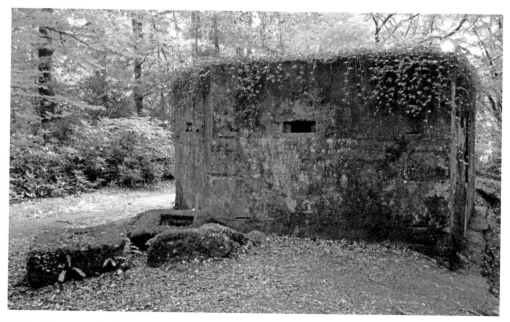

This pillbox, on the bridleway known as The Drift, has a number of concrete blocks scattered around it – possibly anti-tank cubes and roadblocks.

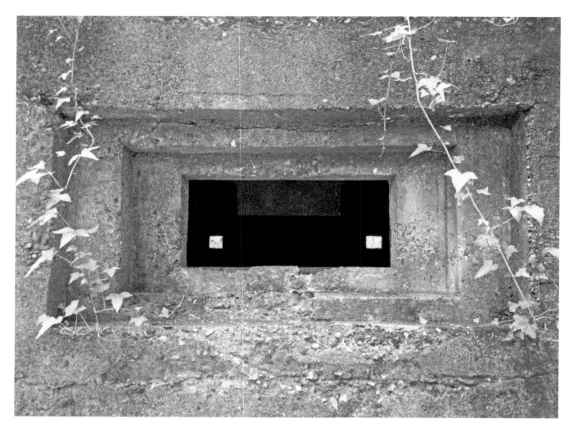

The main gun embrasure allows for a tip-toed look inside the dark pillbox, where the rear gun loopholes are clearly visible.

to see to almost completely overgrown. Some are still in clear rows and others are sitting by themselves in among what used to be large anti-tank ditches. Approximately halfway down the road, you pass Blackland Lane Weir on your right-hand side before you encounter yet more anti-tank cubes and some evidence of an anti-tank wall and roadblock at the entrance of Brickyard Farm. Above you, on a high bank above the railway, there is a pillbox sitting on a concrete platform, but it is largely overgrown and inaccessible.

At this point the lane stops and the track bed of the Chard branch line of the old Great Western Railway, which is now a public footpath, continues over fields as it becomes the Perry Street part of the Forton and Perry Street anti-tank island. Perry Street itself is a small village between Tatworth and Chard Junction. As you head south of the farm and pass yet more anti-tank cubes, you will pass three pillboxes – all on the east side of the railway embankment and facing west – spread out over the next mile. On peering through the embrasure of the first one, you can even just about make out the corrugated iron shuttering still in place on the walls and ceiling. The next pillbox sits on the other side of the hedgerow within the Camping & Caravanning

Club campsite of the Golden Fleece pub and another pillbox is in a private garden as the railway embankment meets the modern road of Perry Street. On the other side of the road there are another three pillboxes within close proximity: one roughly 100 metres along Station Road, within the fields of Bridge Farm, covering the road junction; and two within the fields adjacent to the aforementioned Golden Fleece pub (the first, around 80 metres from the road, is difficult to see as it is buried deep in the hedge, but the entrance and loop holes of the second are a lot easier to spot in the next field from the main road). In total, there are five pillboxes located around Perry Street in a triangular shape, less than 400 metres apart.

Off Perry Street, down the aptly named Factory Lane, there is the Perry Street Lace Mill. Just a stone's throw from Chard Junction, during the war it would most likely have been used to produce items such as parachute silk, mosquito nets and all manner of items relating to uniforms. From here, and the final part of this leg, you can walk along Factory Lane and just about make out an anti-tank cube opposite the sewage works. Continuing along the path, you pick up the final section of the old disused railway track as it would have headed into Chard Junction. Here, the still-existing single-track railway line comes into sight and it is just possible to make out a pillbox and some anti-tank cubes sat atop the western side of the current embankment.

Chapter 7

Dorset: Chard Junction

Chard Junction itself was once a station that served on the West of England mainline. A number of factories and depots developed around it and some are still in existence today. The station has long since closed, although the single railway track is still used, connecting Yeovil Junction and Pinhoe at Exeter. At Chard Junction, the Taunton Stop Line followed the line of the railway track, using the man-made embankments as a basis for defence. It is here, just to the south of Chard Junction, that the Taunton Stop

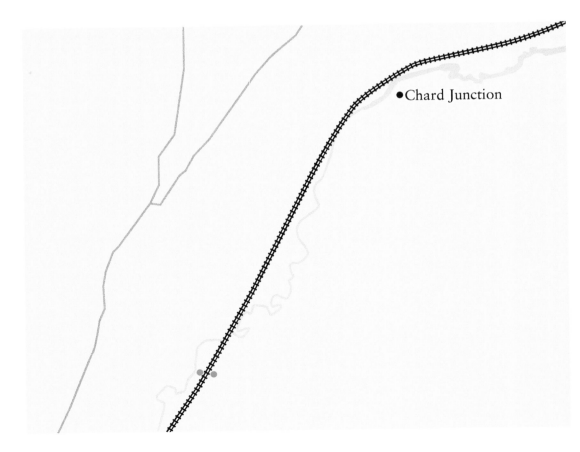

Chard Junction

Line briefly crosses into the county of Dorset for a few miles as it follows the railway track towards the town of Axminster. On the east side of the embankment, around a mile from Chard Junction, there are three pillboxes sat on farmland that are clearly visible on satellite images. Around a mile further on there are more structures visible in the farmers' fields that are to the north of Broom Bridge. Broom Bridge itself crosses the River Axe and there are the concrete remains of a road block just to the side of the road. The road crosses the railway line at a level crossing and in the first field on the east side there is a rectangular Bren gun emplacement made from breeze blocks, which appears to be a variant on the Type 26 pillbox design. The Type 26 pillbox was a simple square design, with each wall measuring approximately 3 metres in length. Unusually, this particular one has the entranceway in the middle of the back wall, whereas it would usually be placed off-centre. This example has very small loopholes, suitable for rifles, and sits in a strategic position overlooking the level crossing. At this point, the Taunton Stop Line's very short journey into Dorset ends as the Devonshire boarder is just a few hundred metres south.

This pillbox at the Broom Lane level crossing, like many along the Taunton Stop Line, sits in a farmer's field with livestock as their main companions.

A roadblock, now partly overgrown but clearly visible, sits on Broom Bridge.

Chapter 8

Devon: Axminster to Axmouth

From the Broom Lane level crossing, the stop line continues to follow the railway track, which now enters the Axe Valley and the county of Devon, and enters the area surrounding the small hamlet of Wadbrook, which is on the site of a Bronze Age enclosure. On the west side of the railway embankment there are two pillboxes around 200 metres apart: one at Broom Cottages, which is inaccessible as the entrance is on the 'active' railway track side, and a rectangular structure almost completely overgrown at Wadbrook Cross.

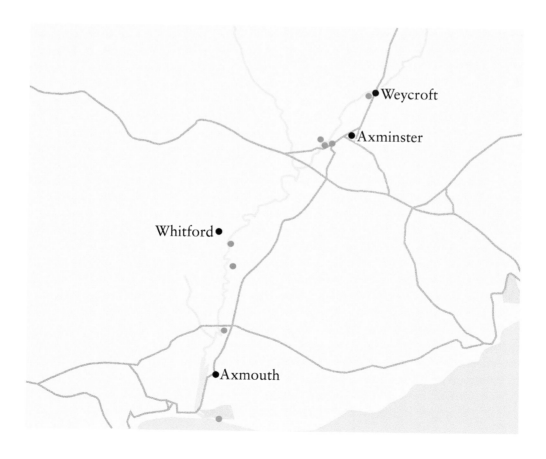

Just to the east of Axe Bridge, opposite Wadbrook Farm and standing in a private field, there is a heavily overgrown pillbox visible from the road, which appears in poor condition due to its exposed position. From here, if you follow the road towards Fortfield Farm, there are two pillboxes clearly visible in the field at the edge of Broom Pits – the site of the Bronze Age settlement – with another at the far end of the field, only visible from aerial photographs and all sat on private land. The first, yet another example of the Type 24 pillbox, sits in the corner of the field and throughout the majority of the year is quite overgrown. It faces west down the lane at a small bend in the road. Made of concrete, it stands at over 6 feet in height and it is possible to make out some of the Bren gun embrasures. In the middle of the field, above a steep slope, there is a Vickers machine-gun pillbox that appears in relatively good condition. Judging by the gun loopholes, its main firing direction would have been in a westerly direction, which would have surprised any potential enemy coming out of the nearby wooded area. The third pillbox, on record as being another Vickers emplacement, is apparently at the far edge of the field but isn't visible from the road. By turning around, heading back the way you came, and taking the next available left turn, it is possible to find another couple of Vickers emplacements in the hedgerow of a field. The first, at a bend in the road, is a thick-walled pillbox that has some evidence of weathering on its external breeze blocks. To the rear of the structure its detached blast wall still stands in good condition, while inside the concrete gun platform is still by the large embrasure. Fifty metres away, its partner stands with some of its external bricks falling away from the structure.

The stop line runs from here to the small hamlet of Weycroft on the northern outskirts of Axminster, which has a large number of defences within its location. This is probably due to the proximity of the Axminster anti-tank island, the fact that the banks of the River Axe in this area are not very high and could therefore be bridged easily, and the location of an army camp near to Weycroft Manor Farm. Wadbrook to Weycroft is around 2 miles as the crow flies but the stop line follows the route of the meandering River Axe, which is no more than 10 metres in width at its widest point in this section. There are five pillboxes along this route, all situated in farmer's fields and all deliberately on the east side of the river. Any potential attacking force would need to cross the railway track, with its man-made embankments causing some hassle, and then bridge the River Axe. The pillboxes along this section, each within 100–200 metres of the next, would have fired on any enemies trying to do so and would have certainly held up the invasion force.

These pillboxes find themselves in a mixed condition. The first, only a few hundred metres from the aforementioned Vickers gun emplacements, is boarded up and almost completely overgrown. There is no access as it sits on the side of a stream in poor condition. The next, at the western edge of Wadbrook Coppice, is also in a bad way, partly covered by moss and creeper and half buried at the corner of the wood. There are records of a third pillbox being at Bagley Hill Farm, although this is within private land, but a fourth structure lies in the open field next to the farm, on Bagley Hill itself above the level of the railway line and River Axe. The fifth, on the bank of the River Axe near Lower Coaxdon, is in fair condition despite the surrounding trees.

As you enter Weycroft, the busy A358 Chard Road crosses over the River Axe, and on your left is the site of the old flour mill, which was listed on the Defence of Britain database as a defended building – no doubt due to its location overlooking the river. Finding a place to park in this vicinity is difficult but worthwhile as a base to explore the Weycroft defences. Opposite the site of the mill, there are a long row of anti-tank cubes along the riverbank with a few concrete posts just about visible, and records indicate that the Weycroft Bridge would have been mined with explosives. Behind the old mill on Lodge Lane there is a public footpath that heads up and over the fields of the manor house in the direction of Wadbrook. At the edge of this steep bank, now within the shelter of the trees, there is a pillbox in good condition. Prior to the trees growing, this pillbox would have had commanding views of the bridge and a good stretch of the River Axe. Being one of the more unusual Type 22 pillboxes (square in its design), it is possible that, as well as providing general defensive fire, it may have also housed all the required equipment for potential bridge demolition. As with the vast majority of pillboxes, it is made of breeze blocks, but these actually cover a brick structure that also has a corrugated-iron roof. Each wall is between 6 and 8 feet in length and it is possible to go inside. On the interior wall its original reference code of 'S33' still remains stencilled there. One hundred metres further along the public footpath, a hexagonal pillbox can be found, mostly covered with ivy. It is reasonably close to the riverbank, slightly upstream from Weycroft Bridge. It is possible to peek inside but access is very difficult as the entrance way is half-filled with mud and soil. Whether this was back-filled deliberately or just a natural result of the bank behind it is not clear, but it does make going inside only possible for the very committed – and the very muddy! Another 100 metres along, as you get to the edge of the wooded area, another infantry pillbox can be found. Close by, to the south-east of Coaxdon Cottages (which lie across the river), there are two imposing Vickers machine-gun emplacements standing side by side in the treeline. Lying just off the public footpath, they face the river (as you would expect) from this steep hillside with good views of the surrounding countryside. They seem to be dug into the bank, have a large main embrasure, and are still just about accessible through the entrance at the rear that is sheltered by an exterior blast wall.

Back at the mill, if you cross the road towards the anti-tank cubes, there is a field that runs alongside the River Axe. As you head up the incline and the public footpath starts heading to the left, there is a heavily overgrown Type 22 pillbox facing north towards the railway line and the bridge, which is unusual in the way its loopholes are designed. With the tree growth at the edge of the field, it is difficult to see the river and railway, but it is easy to get a sense of how high you are and the range of fire this pillbox would have had some seventy-plus years ago. It is actually one of a pair providing cover over the railway bridge, with the other located at the base of the hill. Heading towards the corner of the field a mere 20 metres away, it is a bit of a scramble through a hedgerow as it is hidden at the foot of the slope beneath the bushes and trees. It has no rear embrasure because of the rising bank behind it but it does provide direct cover of the rail bridge that crosses the river.

By continuing on your walk across the field, you join up once again with the railway track where you can see a pillbox just 1 metre from the track. This Type 26 pillbox is square in design and has a loophole above the doorway, which is on the side away from the railway line, and is just about noticeable despite the foliage growing on it. Due to its proximity to the active railway line, the pillbox is fenced off and close access is not advisable. Just along from here there are a pair of concrete buttresses either side of the track that would have acted as railway blocks, but access is again restricted.

Axminster, designated as an anti-tank island, saw its defences based around the River Axe and the railway embankment. In total, there were over twenty pillboxes constructed around the town, as well as anti-tank ditches, road and rail blocks and a lot of anti-tank obstacles. The perimeter of the Axminster anti-tank island formed a complete enclosure of the town, with the route of the Taunton Stop Line running down the western side. Axminster, a town of around 5,000 people, is only around

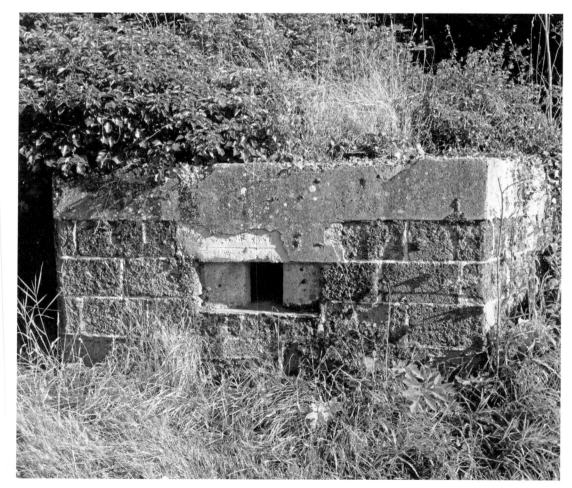

The Type 22 pillbox overlooking the railway bridge at Weycroft from a commanding height.

Pillboxes can be spotted in farmer's fields right across the Axe Valley.

8 miles from the coast, which explains why the defences here were so important. The United States Army had a base in the town, which contained the 29th Field Artillery Battalion and the 315th Station hospital headquarters located at Millwey Rise before and after the D-Day landings. The 29th Field Artillery Battalion contained twelve Howitzers – massive artillery guns that could fire up to a distance of 7 miles. It is likely that continual practice in the countryside around Axminster would have been ongoing right up until the D-Day landings, when they would have relocated to France.

It is actually difficult to fully establish where the Axminster–Weycroft boundary is as they both follow the river. But by continuing along the fields, you end up at Axminster Bowling & Cricket Club, which is on the north-western edge of town and seems a sensible place to start. Turning right here will lead you to the small Cloakham railway bridge, where there are two pillboxes – one on the north side and one on the south side. By crossing the bridge and looking back towards town, it is

possible to make them out despite the dense brambles and shrubbery. The north one in particular, painted in white after the war, is easy to make out and even more so if you visit during the winter or spring months when the vegetation is at its lowest. Looking north from the bridge itself there appears to be an anti-tank cube and the buttress of a railway block.

There are a number of well-preserved emplacements along the western edge of the town, and by following the public right of ways across the farmland it is possible to see them. The stop line follows the railway to Axminster train station, which has a number of emplacements within very close proximity. Standing on the road bridge that carries the B3261 over the tracks, it is possible to look north and see a pillbox on the embankment. From here, head out of town for approximately 100 metres and you will reach a small off-road parking area just before Bow Bridge (which carries the road over the River Axe). On the western side of the bridge there is a roadblock and in the field behind there is a gun emplacement in good condition, which would have been a significant 6-pounder anti-tank gun. These emplacements were built to the simplest possible standard and the smallest possible dimensions, and there is a massive opening for where the gun would have been. As the guns would always have been in position, they would most likely have had a removable front cover, but this has long since gone. Inside the emplacement, which sits no more than 2 metres from the river and around 20 metres from the bridge, the metal gun stand is still in situ, and you can still see the shell recesses where the ammunition would have been stored. With the surrounding flood plains being so flat, the gun would have had an impressive range of covering fire. It is also a fine testament to those who built the emplacement that it is still in such good condition more than seventy-five years later.

In the adjoining field, towards the line of the railway embankment, there are two infantry-style pillboxes hidden among the trees and the undergrowth. If you follow the treeline further, you arrive at the south-western edge of the town, within sight of the A35, and over the other side of the railway track, now within the boundaries of the Horselears Water Treatment Works, are an infantry pillbox and a Vickers machine-gun emplacement. Access is out of bounds, but it is just about possible to view them by walking down Abbey Close to the entrance of the site. In the adjoining farmer's field, just to the north of the A35, records indicate that there are another set of structures like the last.

The anti-tank ditches that once surrounded Axminster have long since been filled in and a number of pillboxes that were built to enclose the town on its eastern side have long been lost to the building of houses. From the edge of Axminster, the stop line continues to roughly follow the path of the railway and the river. Shortly beyond the A35, the River Axe crosses beneath the railway and, from here, the pillboxes can be found on the eastern side of the river with the railway on the western side.

Between Axminster and the small town of Whitford a few miles away, there are at least fourteen structures, with five of them being just on the outskirts of this tiny village. It is here that the West of England main line, which for so many miles had been providing a man-made defence with its embankments, veers off to the west,

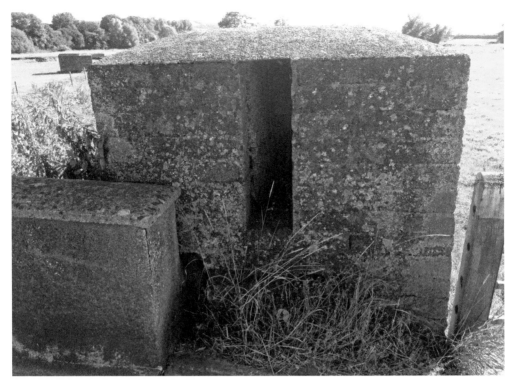

The roadblock on the western side of Bow Bridge, with a nearby pillbox visible in the background.

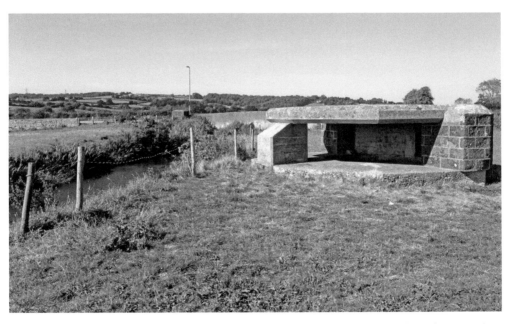

The emplacement for the 6-pounder gun sits no more than a few metres away from the River Axe.

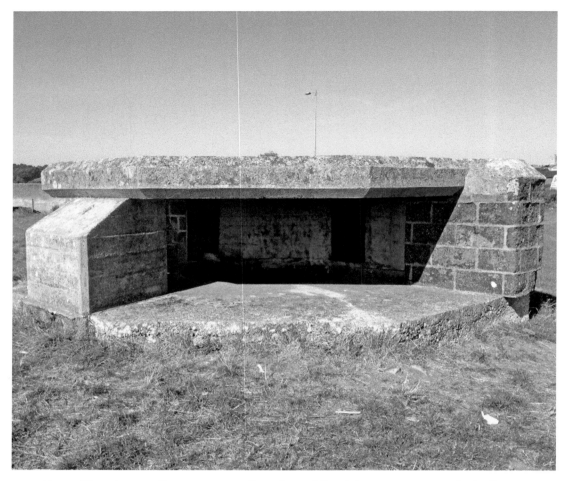

Above: There is a small supporting wall in the middle of the gun opening, which allows a 180-degree field of fire.

Opposite: The metal gun stand is still in place as are the shell recesses used for storing ammunition.

heading through Seaton Junction and in the direction of Honiton. The pillboxes here are in a variety of conditions: some being covered by fallen trees, one being undermined by the river and tilting into the water, and the vast majority are being reclaimed by the vegetation around them. However, heading along Whitford Road towards the village of Whitford, two pillboxes are visible from the road in fields to the north and just prior to Whitford Bridge there is a public parking area where it is possible to head off into the fields and explore. To the south of the road there is a popular picnicking area right on the banks of the River Axe, and just over 100 metres away in the next field is a half-covered pillbox that has the date '1940' engraved on its doorway.

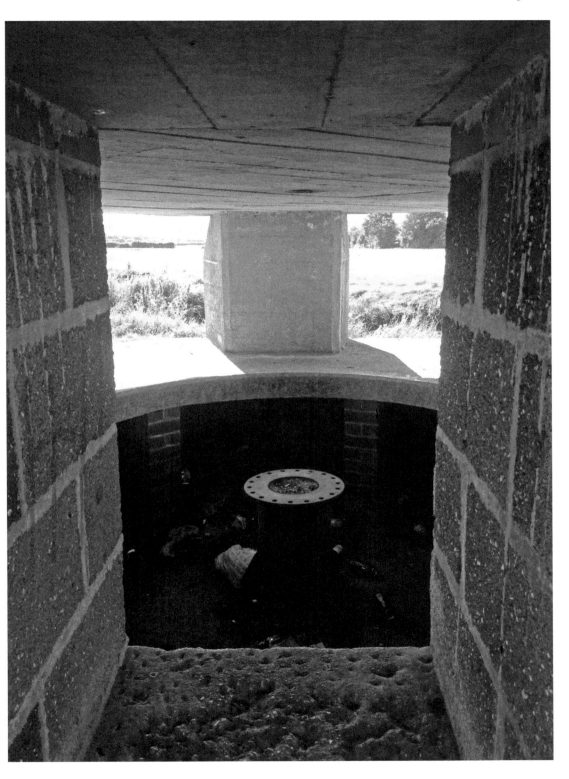

The stop line continues along the east side of the River Axe as it continues to meander the remaining 4 miles or so to the coast. By following the public right of way through these fields, there are at least another ten or so defensive features over the next 2 miles towards Boshill Hill. Due to their locations – somewhat off the beaten track and away from any maintenance or upkeep – they survive in a range of conditions. A good half a mile south of Whitford, the next structure is in good condition. It can be found set against a hedge at the end of the lane that takes you to Waterford Farm. At the water's edge, at the end of the next field, there is a pillbox in good condition and another two within 250 metres – again, within close proximity of the river. By sticking within sight of the river you gradually continue south, passing more concrete pillboxes. In this stretch they are all almost identical in their design and, due to their isolated location, entering them can be a bit foreboding. The final few fields see three pillboxes within 200 metres of each other, the last being around 10 metres from the road and hidden behind a hedge by the field access point. For those not wishing to trek the 2 miles on foot, it is possible to drive from Whitford to the Tanyard Cross Junction on Boshill Hill along the A358 Roman road, which runs almost parallel to the stop-line route and takes no more than five minutes. The Axe Bridge on the A3025 has a pillbox with block shuttering easily visible at the side of the road, right next to the gate of a farmers field.

Just next to the crossroads at Tanyard Cross and the other side of the Axe Bridge, there is a splendid 6-pounder anti-tank emplacement. Positioned in a field overlooking the River Axe, and indeed the whole Axe Valley, it is easily visible from the main road and definitely worth a visit. There is plenty of space to pull over off the road, with a bit of care needed to walk across the busy A3052 that links Exeter and Lyme Regis. Made of concrete with brick outer walls, its gun opening offers a 180-degree view over the empty fields. With the single entranceway at the rear of the structure, the inside can actually be quite dark, even if visiting with glorious sunshine. The structure is very simple in its construction, with just the one 'room' internally – the one that would have housed the gun. The gun and its support have long since gone and rubble now lies strewn across the floor. You can, though, still see the shell recesses that would have housed the ammunition.

It is possible to walk the final 2 miles across the fields towards Axmouth, where you will encounter more pillboxes that aren't all visible from the road. Within sight of the anti-tank gun, there is a pillbox around 300 metres south of the A3052. It is so close to the River Axe that it appears to have started to be undermined by erosion and, coupled with the thicket growing, it would be unwise to enter. There are also records that show another pillbox right in the hedgerow by the B3172, just south of the crossroads. It is probably still there, however no evidence could be seen, likely due to the significant vegetation growing. At the bottom edge of the field, there are two Vickers machine-gun emplacements in quite good condition. Located 50 metres apart, they stand in the shadow of the nearby road but due to the hedgerow they are not visible while driving. They seem to both be located above the flood plain of the River Axe and have a field of fire in a westerly

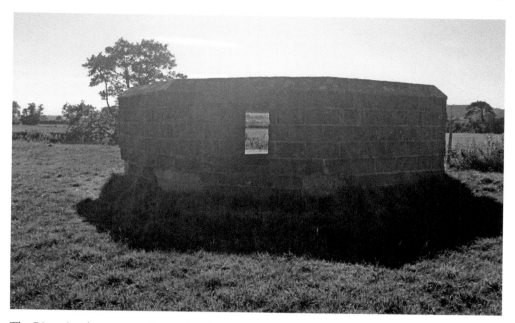

The River Axe has many relics of the Taunton Stop Line still standing guard on its banks.

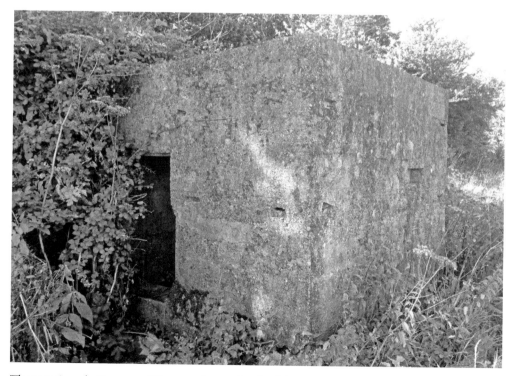

The remains of a Type 22 pillbox on the east bank of the River Axe, a little over 100 metres from Whitford Road.

direction, across the river. Rectangular in plan, the higher one is sunk well into the ground, with the gun embrasure at foot level and only around 2 feet of concrete still visible. The entrance is completely blocked up and access is impossible but the views are superb and this is a peaceful setting to have a picnic and survey the countryside. The lower emplacement stands above ground and has an external blast wall protecting the entrance that has been blocked up. Like its neighbour, the views across the fields are wonderful.

Carry on walking down towards the coast with the river on your right-hand side and the nearby road on your left, and you pass another four structures before entering the small village of Axmouth. The first pillbox, equidistant between the road and river, shows some signs of erosion, as does the second emplacement, which is half set into the ground hidden in a hedgerow near the road. Staying close to the road, it is possible to make out a third pillbox that has been incorporated into the verge around 200 metres further along, and the final one is submerged in brambles on the bank of the River Axe Estuary at the very edge of Axmouth campsite.

Axmouth, a village of less than 500 people, is the final point on our journey along the Taunton Stop Line. The village itself is around a mile from the mouth of the River Axe, but the parish boundary extends right down to the seafront, with the larger town of Seaton sitting on the opposite side of the river. All coastal towns along the English Channel had defences in place during the Second World War, and here these formed the final part of the stop line. From the town, the B3172 follows an almost straight line for around a mile as it runs parallel to the River Axe towards the harbour. Along this route, in the fields that are above the road, there are a number of structures. There is a pillbox within the back garden of a house and another around 200 metres further along, hidden behind the hedge at the side of the road. At the end of the next field, not visible from the road, there are a row of four defensive buildings, two Vickers machine-gun emplacements (sunken into the ground) and two pillboxes on either side of them. The views from these pillboxes, overlooking south-west over the Axe Estuary and around 500 metres from the Axmouth Bridge, are amazing and would have provided the Home Guard with excellent sight of any approaching invasion force. There are parking spaces along the side of the B3172, which get filled up quickly during the summer months by people visiting Axmouth Harbour. However, by parking here, you can walk down as far as Squires Lane and head up the track towards the Axe Cliff Golf Club. Along the steep climb, it is possible to find the public right of way that allows you to head back through the fields and see the aforementioned structures and the views.

The Grade II-listed Axmouth Bridge, which carries the B3172 into Seaton was, like all significant bridges along the stop line, mined for demolition. It was also defended by a pillbox located above the east bank of the river that was able to cover the approach to it from the mouth of the river. The pillbox is still easily visible from the road but sits within the private land of Haven House, which, according to records, also has a further two pillboxes within its boundaries.

From here there is a picturesque quarter of a mile walk along Axmouth Harbour passing beach cafés and numerous boats to get to the final structure of the Taunton Stop Line. The remnants of the Coastal Artillery Beach Battery can still be found above the mouth of Axmouth Harbour in a position that overlooks both the harbour and the English Channel. With its brick cladding now eroding, the majority of the structure is overgrown and the entrance no longer visible. In front is the site of the Haven Cliffs picnic spot, where seats on a wooden boat-like structure have been built on top of a large concrete construction that was certainly part of the coastal battery. It is the perfect place to finish the Taunton Stop Line journey. It enables you to sit back and look across the blue waters of the English Channel and imagine what members of the Home Guard were thinking some seventy-five years ago as they prepared to be the first point of contact against any Nazi invasion, and it is somewhat fitting that you are able to do so with an ice-cream in hand, in the freedom they were prepared to protect.

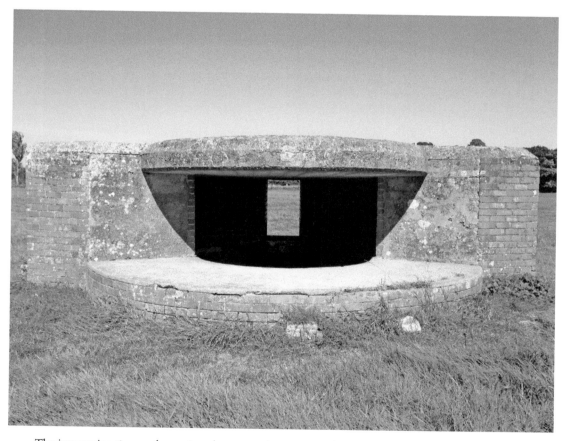

The impressive 6-pounder anti-tank gun emplacement at the Tanyard Cross crossroads.

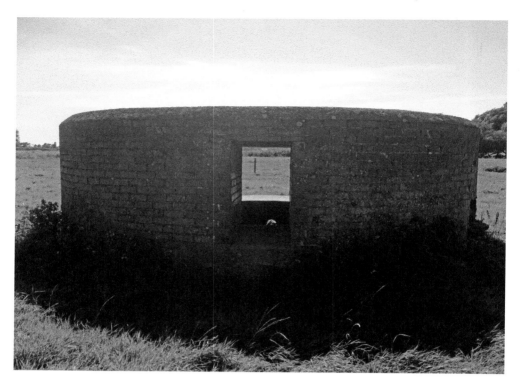

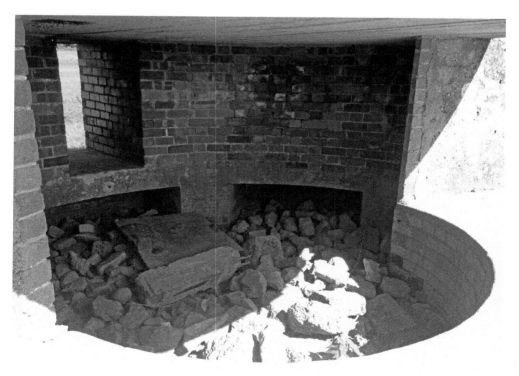

Above: A new seating area has been installed just in front of the pillbox overlooking Axmouth Harbour.

Opposite above: The single entrance way at the back of the structure is quite small and narrow.

Opposite below: The inside of the anti-tank emplacement is now sadly full of rubble.

The structural remains of the Coastal Artillery Beach Battery is now used as a picnic spot.

The stunning panoramic vista from the site of the final emplacement on the Taunton Stop Line, overlooking the English Channel and the mouth of the River Axe.

Chapter 9

Lasting Legacy

The unanswerable question is: Would the Taunton Stop Line have worked? Thankfully, it was never put to the test. Operation Sea Lion, Hitler's plan to invade and conquer Britain, never came to fruition, as the führer decided to postpone the attack in September 1940. The lack of air superiority, thanks to the heroic efforts of the Royal Air Force in the 'Battle of Britain', combined with the strength of the Royal Navy in the English Channel, meant that realistically, there was very little chance of success. Hitler therefore decided to look elsewhere to flex his muscles, namely Operation Barbarossa and the invasion of the Soviet Union in 1941, which significantly reduced the threat to British shores due to the large number of troops that were involved and shifted focus back to mainland Europe. With the United States of America entering the war in December 1941 after the Japanese attack on Pearl Harbour, Great Britain saw tens of thousands of US soldiers land on her shores, bolstering its defences and essentially bringing the threat of invasion down to nil.

But, had the Nazis landed on one of the beaches of the South West, or parachuted onto the great swathes of farm and moorland that sweep the region, would they have been stopped?

It is important to remember that the aim of the Taunton Stop Line was never to actually halt the advancing enemy, but to 'make them bleed' before achieving their goals. As General Ironside himself had pointed out, they 'are only meant as delaying lines, and are meant to give the mobile columns a chance of coming up to the threatened points.'

So what would have happened? Any detailed air reconnaissance of Britain in 1940 by the German Airforce, the Luftwaffe, meant that the stop lines zig-zagging across the country would have held few surprises for the attackers. However, the stop lines would certainly have been a thorn in the side of the enemy and the Home Guard, although significantly under trained and ill-equipped to face the well-oiled Nazi fighting machine, would at least have had the advantage of knowing the lay of the land. It is reasonable to suggest that they would have held up a potential invasion force, but for how long is a different matter. Long enough for reinforcements to arrive from other parts of the country? Long enough for the Royal Navy to cut-off their supply routes back to mainland Europe? With the combination of manned concrete emplacements, minefields and obstacles, as well as the natural geographical features, that was the hope.

In the dark days after Dunkirk in the summer of 1940, with a lack of trained operational units available and where invasion by the seemingly all-powerful, all-conquering Nazi war machine seemed a distinct possibility, the construction of the Taunton Stop Line, and others across the country, would have at least acted as some sort of deterrent. Just as importantly, despite costing large sums of money, raw materials and man power to create, the Taunton Stop Line would have certainly lifted the morale of the local civilians and its existence would have allowed greater confidence to be placed in the Home Guard, meaning that any trained troops manning the static defences could be released for other duties. As the threat of invasion subsided, this was exactly what happened, as operational units prepared themselves for D-Day, leaving the Home Guard volunteers in charge.

By the middle of 1945 the Taunton Stop Line was well and truly redundant. With Hitler dead, the Nazis defeated and the war in Europe over, anything that was recyclable, such as wood and metal, was taken and used to help rebuild the war-torn country. For those farmers whose land was used for the various structures, compensation of up to £5 (approximately £150 in today's money) was paid for them to fill in the ditches and demolish the pillboxes. However, for some, the challenge of demolishing them far outweighed the actual time and effort required to do so, and it is evident across the South West that a number of farmers didn't, or probably couldn't, destroy them. Sadly, many of the structures have been lost to erosion and modern construction, particularly in the towns, where the need for new buildings and roads has regrettably outweighed the preservation of our past. For those remaining structures, nature has done a good job in reclaiming and camouflaging them, and the battle against neglect and ruin is now the only one being waged.

However, it is somewhat fitting to the memory of all those involved in the planning, building and manning the Taunton Stop Line that, more than seventy-five years on from their initial construction, there are a large number of structures still surviving in the hedgerows and fields – still on duty, protecting the land before them. Today, they stand as solitary reminders of a bygone era, of a time when Britain was at her greatest peril, where everyday members of the Home Guard were prepared to protect the tranquil rolling countryside and the way of life of the South West of England. Lest we forget.

Acknowledgements

Researching this book has been a real labour of love. Having moved to Somerset in 2012, it was amazing to discover so many relics of the Second World War dotted around the countryside, and really quite staggering that so little has been written or published about them. So few people in the area actually know about the real history that lies, literally, on their doorstep, and there is a danger that, unless the next generation are

A lone pillbox at sunset overlooking the River Parrett in Bridgwater.

made aware of these remarkable remnants of their families' past, it could easily be lost. For the amateur historian like myself, who revels in the opportunity to actually visit sites and get a sense of what it would have been like at the time, this book sets out some of the locations, what you can expect to find there, and the general background to the Taunton Stop Line.

I would like to thank Alan Murphy, Rochelle Stanley, Jenny Stephens and all at Amberley Publishing for their help in making the project become a reality, as well as my wife Laura and young son James, who accompanied me on many beautiful walks and day trips around the glorious Somerset countryside, with just the occasional picnic and 'strategic' pub lunch thrown in! In many ways, I feel it is quite fitting that my family and I have had so many enjoyable moments at the very places where so many ordinary men and women were prepared to give their todays for our tomorrows.

Andrew Powell-Thomas
January 2017

Bibliography

Ironside, Sir Edmund, *Time Unguarded: Ironside Diaries* (Greenwood Press: 1974)
Defence of Britain Project, http://archaeologydataservice.ac.uk
Imperial War Museum Collections, http://www.iwm.org.uk
Second World War Stop Line, The Taunton Stop Line, Somerset Historic Environment
 Record.
Somerset County Council, http://webapp1.somerset.gov.uk
Somerset Pill boxes, http://www.pillboxes-somerset.com
Pillbox Study Group, http://www.pillbox-study-group.org.uk

All photographs have been taken by the author.